9/12

To the Nix Family
Modern Oak Park Pioneers

Bob Nix
June 2002

IMAGES
of America

OAK PARK
ILLINOIS
CONTINUITY AND CHANGE

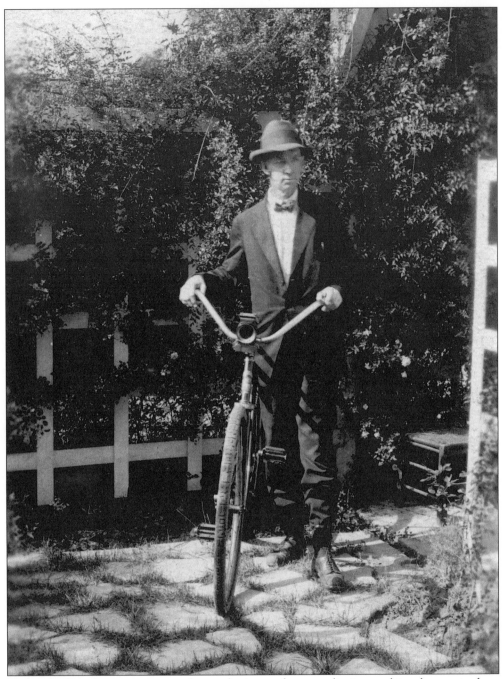

Philander Barclay was a man of complexity and contradiction, a bicycle repair shop owner who spent just as much time on his hobby of photographing and gathering material related to the history of Oak Park for almost forty years. He also annotated his pictures of streets, utilities, buildings and people, providing an invaluable record of life in the Village during a seminal period. His collection is preserved at The Historical Society of Oak Park and River Forest: call (708) 848-6755 for help with your Oak Park research.

IMAGES
of America

OAK PARK
ILLINOIS
CONTINUITY AND CHANGE

David M. Sokol

ARCADIA

Copyright © 2000 by David M. Sokol
ISBN 0-7385-0712-1

Published by Arcadia Publishing,
an imprint of Tempus Publishing, Inc.
3047 N. Lincoln Ave., Suite 410
Chicago, Il 60647

Printed in Great Britain.

Library of Congress Catalog Card Number: 00-102086

For all general information contact Arcadia Publishing at:
Telephone 843-853-2070
Fax 843-853-0044
E-Mail sales@arcadiapublishing.comt

For customer service and orders:
Toll-Free 1-888-313-2665

Visit us on the internet at http://www.arcadiaimages.com

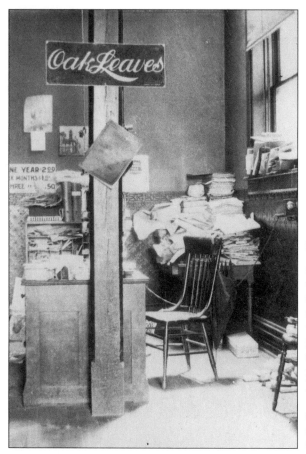

A number of newspapers were born in the last twenty-five years of the nineteenth century, but only *The Vindicator* was successful. Both *The Vindicator* and its rival, *The Oak Park Times*, were succeeded by *Oak Leaves*, a newspaper of local record, first appearing in January 1902. This is the original office of The Pioneer Press, its publisher since 1913, in the first or second year of publication. Its complete run and photographs are preserved at the Historical Society of OPRF.

CONTENTS

ACKNOWLEDGMENTS

I am indebted to many people for their help and courtesy as I sought photographs and information in the preparation of this book on the community I have called home for almost thirty years. I am thankful to those organizations and individuals who either supplied the photographs, as credited, or who provided suggestions and sources for other images. I am particularly indebted to the Park District of Oak Park, Downtown Oak Park, and the Oak Park and River Forest Chamber of Commerce for access to their files.

This project could never have been undertaken were it not for the rich resources and wealth of both historic and recent photographs in the collection of The Historical Society of Oak Park and River Forest. All images not otherwise credited are courtesy of that body. The Society has amassed an abundance of images from many sources including the photos of the turn of the century amateur photographer Philander Barclay, and those images donated by *Oak Leaves*.

Every such volume is a collaboration. I am deeply indebted to two individuals who contributed in important ways: Frank Lipo, the Executive Director of The Historical Society of Oak Park and River Forest, has been involved in every stage of this project by contributing ideas, offering thoughtful criticism and suggestion when needed, and by providing an image, a date of an event, or a source in which to search; my wife, Sandra Sokol, has not only served as an excellent sounding board through the many stages of image selection and sequencing, providing suggestions about what is important in Oak Park, but has also put up with my eccentric hours and the tendency of this project to take over all available space in our home.

The choice of images in this volume is, obviously, subjective and personal. Another person with a different perspective would select different images, organize them in different ways, and would create a different book. In spite of the help and suggestions I received, the final selection, presentation, and responsibility for the appeal or value of the book are mine.

INTRODUCTION

Oak Park will be celebrating its Centennial in 2002, justifiably proud of its reputation as a community with world-renowned architecture and as the home of men and women who have achieved distinction in the arenas of science, the arts, religion, and business. Oak Park celebrates its diversity, looked to as a pioneer in the areas of open housing, racial diversity, and as the home of organizations dedicated to the elimination of every form of discrimination and social injustice. Situated just west of Chicago, Oak Parkers have long enjoyed easy access to the city, its employment, its cultural and commercial opportunities, as well as everything else a great metropolis has to offer. At the same time, the Village has benefited from its independence and ability to self-govern, run its own schools, develop its own recreational facilities, and largely determine its own destiny. All units of local government: The Village, Township, Elementary School District 97, Park District and Library Board are coterminous; each containing all of Oak Park and only Oak Park. Only District 200, the High School District, embraces more than the Village as it includes all of the smaller sister village of River Forest.

The village of Oak Park is a Home Rule Community under the guidelines of the State of Illinois, giving it a great deal of autonomy. Governed by an elected President and Board of Trustees and administered by a Village Manager and staff, this home rule community provides fire and police protection, sanitation services, street maintenance, and the licensing of businesses. The Village is the dominant unit of government in the lives of its citizens. The Township provides social services, the Park District administers the parks and recreation programs, and the Library Board is responsible for the three public libraries in the community. Eight elementary schools, two junior high schools which are soon to become middle schools, and the large high school shared with River Forest are the providence of the two school districts. Utilities and public transportation are provided by regional servers. The community enjoys strategic advantages of a Lake Michigan water supply, a railroad station, and two public transit lines into Chicago and the two major airports.

Oak Park was formed out of the Cicero Township, which once included Berwyn, Cicero and Chicago's Austin neighborhood, and is composed of the two former villages of Ridgeland and Oak Ridge. The Village's boundaries are Austin Boulevard to the east, Harlem Avenue to the west, Roosevelt Road to the south, and North Avenue to

the north. North to south, Oak Park is four miles long while ranging one and a half miles wide, with a 52,500 resident population in 1990 and a peak population of over 62,000 at the end of World War II. The community is extremely diversified in age, religion, ethnicity, race, and sexual preference. It has been a town of commuters into the Windy City especially after the Chicago Fire of 1871, yet Oak Park has always been home for people locally employed. There are many whose families have resided there for generations, corporate transferees, and the urbanites for whom the community has become the place of choice when faced with making school choices for their children.

Housing patterns have changed in the 150 years of residential development; farms are gone, many large Victorian mansions have been razed to provide more moderately sized homes, and various forms of apartment living have developed. The continued conversion of apartments into condominiums has meant that more units are in personal ownership than at any time in our history. The construction of town houses on every available piece of land is increasing the density and ending the population decline that was the result of the decrease in family unit size. Housing costs were low during the 1970s as fear of racial change forced some residents to flee the community, but costs have exceeded the growth rate of many Chicago area communities. Oak Park still remains a very desirable place to live.

Conscious efforts toward economic development have become more necessary with the loss of sales tax income that accompanied the departure of the automobile dealerships for exurban locations and the reality that regional shopping malls have lured the department store anchors out of downtown Oak Park. Village officials, the local financial institutions' funded Oak Park Development Corporation, and the Chamber of Commerce of OPRF have worked diligently at filling retail vacancies, bringing new development to the community and brokering partnerships when necessary. The removal of the longtime ban on liquor sales and the population diversity have resulted in an Oak Park that has a remarkable number of different restaurants at every level of cost and appeal. New anchors and branches of major retail chains have been attracted to a revitalized downtown Oak Park. At the same time, antique shops, used books stores, art galleries, and boutiques provide more of an urban feel than is customary in suburban commercial centers.

The largest and most rapidly growing industry in Oak Park is tourism. The over twenty homes designed by Frank Lloyd Wright and a larger number by his followers in the Prairie School as well as the heritage of native son Ernest Hemingway have brought tens of thousands of people into Oak Park each year. Additional attention has recently been paid to other historical sites and people too. The promotion of tourism without undue stress on the citizens, the infrastructure, or the attractions themselves, is an important challenge for the coming decades.

Oak Park has been a pioneer in open housing, a community that developed a Housing Equity Program to assure those who feared racial change and diversity. The Exchange Congress is a forum for discussion of those important issues within the context of generating economic development. It has encouraged open discussion and the creation of public solutions to such difficult social issues as gun ownership, the needs of the homeless, social diversity, and cultural and religious pluralism. Oak Park may not have all the answers, but the community has developed a national reputation for the frankness of its attempts to look at issues and as a living laboratory where its citizens continue to participate in an admirable tradition of continuity and change.

One

STREETSCAPES

Joseph Kettlesrings purchased 173 acres of land for $215.98 in 1837. This purchase included the land between Harlem and Oak Park Avenues and between Chicago and North Boulevard. He sold off pieces in 1848, with substantial division in 1856. Milton Niles and James W. Scoville bought land to the south and east of Kettlestrings' and subdivided it to encourage settlement. Ridgeland, or today's East Oak Park, was subdivided in 1872 and the lots sold quickly in the aftermath of the Chicago Fire. The area south of Madison was settled as a result of Gunderson and Hulburt's planning and construction after 1900. North Oak Park rounded out the boundaries between 1910 and the start of the Depression.

The streets were laid out early, providing a uniform grid that facilitated basic services and utilities. Both workers' cottages and mansions appeared, yet farms continued in the north and south stretches of the community until the early twentieth century. Slowly, properties were subdivided with smaller homes built on the side or back lot. Homes built on speculation might be of the same design, though there was very little mass subdivision development in Oak Park after Gunderson's. Two flats appeared at the end of the nineteenth century and multiple apartment buildings around 1910. The major burst of large apartment buildings occurred in the 1920s.

Building activity slowed between the start of the Depression and the end of World War II. Post WW II Oak Park saw a great demand for housing. However, this new demand forced the division of many large home into apartments. Condominium construction was important in the 1960s followed by two great waves of condo conversion in the late 1970s and late 1990s. New construction is in great demand at the turn of the century, but little land is available.

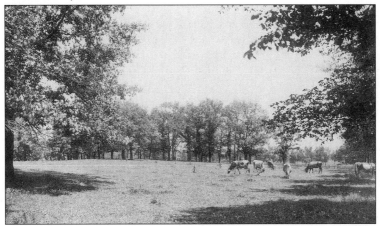

Part of the Austin farm before 1890, the area called Fair Oaks was an animal pasture when photographed in 1896. It included North Central Oak Park and later became an area of fine brick homes. With plenty of trees, adequate water, and proximity to the settled part of both Ridgeland and Oak Ridge, the area was popular with full-time farmers and affluent neighbors who looked to pasture their horses away from their substantial homes to the south.

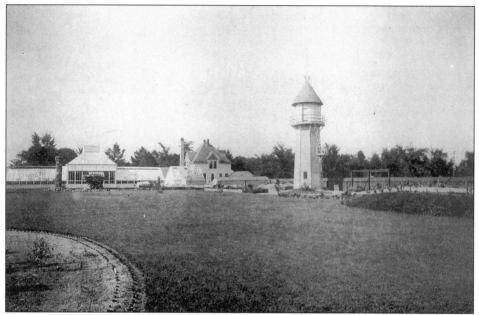

This 1896 image of Mr. Freer's residence conveys the scope of successful county estates in Oak Park. Vegetable gardens, grazing, milk cows, a greenhouse, a silo, and the equipment necessary to run a self-sustained operation are all evident. There were also specialized farms, providing fruits and vegetables, flowers and even meat for the stores of downtown Oak Park and for local retail customers as well.

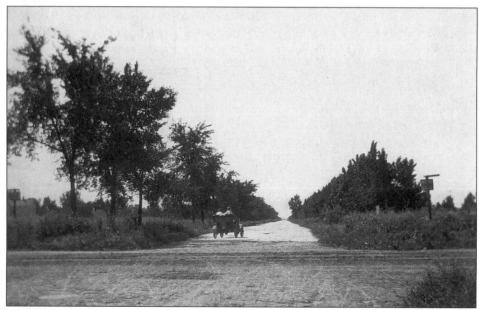

Looking south on Austin from Madison in 1903, one is able to see how late the east central part of the community developed. The automobile riders have just crossed the ungated railroad tracks. There were few homes in this area at this time, but it soon filled up with private homes and with multi-unit buildings along Austin Boulevard.

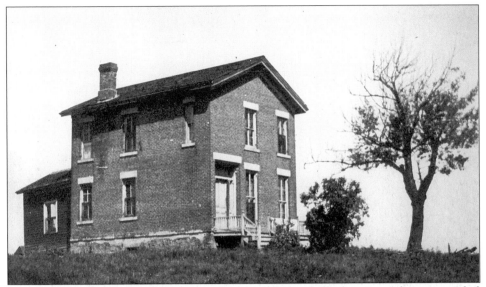

This small brick farmhouse sat on the top of the hill that was the apex of the continental divide at Ridgeland and North in the late 1890s when the entire area was still used for farming. The commanding view and sharp slope to the east and south were unsuitable for farming but provided a dramatic site for the residence of the farmer's family.

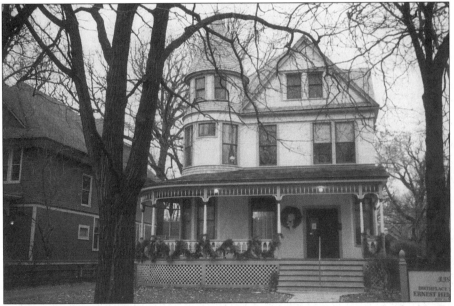

This large Queen Anne home on North Oak Park Avenue was built for Ernest Hemingway's grandparents in 1890, eventually proving to be the domicile where the future Oak Park author would be born. The setback from the street, the large wraparound porch, wood siding, and turret are all typical features of the large Victorian era homes occupying such solid professionals and businessmen as Mr. E. Hall and his physician son-in-law. The houses contained many bedrooms and other rooms for both the family and its servants. (Photo courtesy of Ernest Hemingway Foundation.)

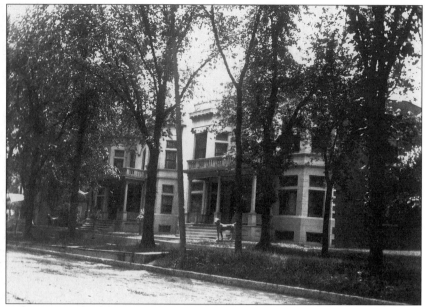

Groups of two-story buildings, such as this 1897 image of Hascall's Flats located at 231-241 South Maple Avenue, were among the first of the multi-unit structures erected in the community. Residents were horrified at the thought of such housing. Newspapers predicted the spread of disease and the end of suburban living if these structures were allowed to proliferate and inhibit the circulation of air and an access to greenery for their occupants.

The Kenton, at 112-114 South Home Avenue, was the first residential hotel developed in Oak Park. Built and 1897 and pictured here in 1903, it contained both apartments and public spaces, including a dining facility and a social hall that offered scheduled events to the public. By 1902, all such multi-apartment buildings were required to be built of fireproof materials. The building was completely renovated in the late 1980s.

This early postcard portrays the entrance of Elizabeth Court, off Forest Avenue. The home was named after Elizabeth Humphrey, the wife of a prominent minister in the area. The curving street was the result of resistance from Forest Avenue neighbors towards any east/west street extensions from Harlem through their area. The compromise was this one street without an outlet, curves that create a more varied face of the homes to the street.

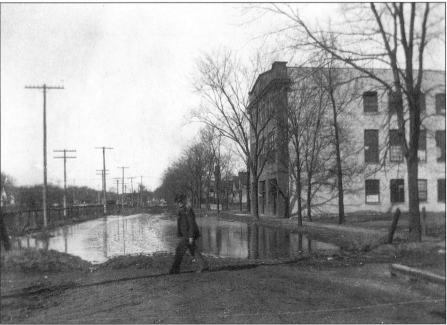

Looking west on North Boulevard from East Avenue, one can see just how prone to flooding the streets were in this 1903 photo. Plans to even grade and gravel streets were opposed because of their cost. Many of such commercial streets were paved with cedar blocks in the 1890s but they could not handle automobile traffic. Asphalt, brick, and other materials were used on graded streets by 1910, and the seasonal flooding ceased.

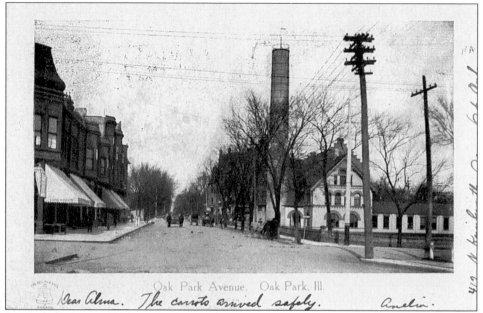

Oak Park Avenue. Oak Park, Ill.

Dear Alma. The carrots arrived safely. Amelia.

This penny postcard of 1908 shows Oak Park Avenue, looking north from North Boulevard, a secondary retail area. The Cicero Water, Gas, and Electric Company is on the right. There were substantial residential areas both north and south of this area, though much of it was soon replaced by commercial buildings like those to the left.

Photographed in 1912, The Plaza Hotel on South Marion was built to accommodate visitors to the Colombian Exposition of 1893. Although constructed quickly for a particular market and later expanded and converted to single occupant housing, it contains some excellent glass and a still impressive stairwell. Already almost vacant for a decade, a 1993 fire created the possibility for its current restoration and remodeling as part of an expanded Carleton Hotel.

By the time the Village reached its maximum population around World War II, the elm trees that replaced the earlier oaks had developed stunning canopies on the north/south residential streets as seen in this 1979 photo of the 1100 block of South Wenonah. Dutch Elm Disease took hold and many trees were lost in the 1960s and early 1970s. A massive containment and restoration program was started, but the destruction continues.

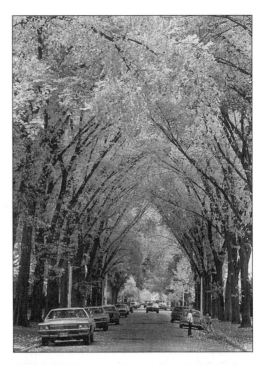

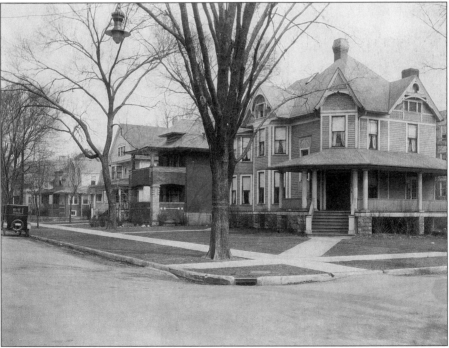

This house at 300 North Grove is a wonderful example of Victorian exuberance and eccentricity. The unusual corner entrance and steps leading to the juncture of the two streets made the home a beloved landmark when it was slated for demolition to make room for what itself became an important structure on the site: An Art Deco apartment house of 1927, designed by E.E. Roberts and his son.

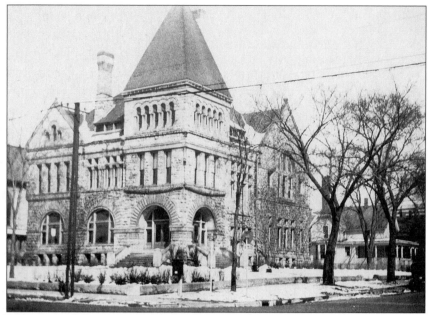

This 1928 view of the corner of Lake Street and North Grove shows the side of the First Congregational Church on the left, Scoville Institute on the site of the current Main Library, and the edge of the old house to the north. Scoville Park is to the east and a residential hotel is south across Lake Street, presenting the complexity and eclectic nature of just one corner of Oak Park.

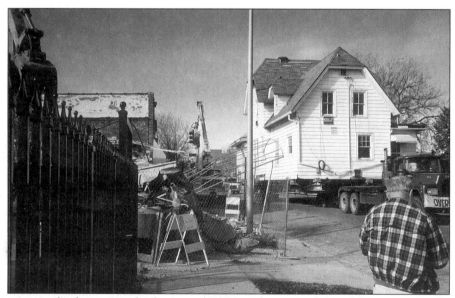

This vernacular home was built around 1870 and is one of the oldest surviving homes in the community. It was the residence of First Congregational pastors and then a series of physicians and was adjacent to and owned by the Library until 1999. In danger of demolition for library expansion, many citizens worked to ensure its survival by moving it to a new location and restoring it for residential use. (Photo courtesy of William Cassin.)

Through the years, and still continuing as the price of land increases and real estate taxes climb proportionately, the owners of large homes have sold off their side lots for construction of additional, but smaller homes. On streets like the west side of North Kenilworth, there is an almost regular pattern of side-lot development. This 1999 photo depicts side-lot houses fronting on Chicago Avenue. (Photo by author.)

This 1983 photograph of 213 South Grove indicates the trend in restoration and rehabilitation that has taken place in Oak Park for 30 years. Aluminum and asphalt siding is removed, wood repaired, decorative details are replaced or recreated. Less visible improvements include insulation, updated heating systems, as well as adequate wiring and plumbing. Programs of the Historic Preservation and Design Commissions recognize such efforts with annual awards.

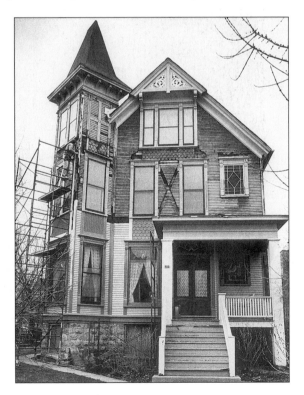

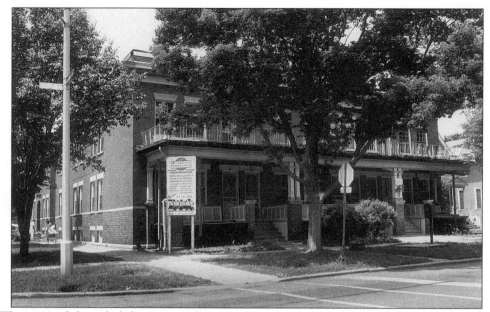

The start of the rehabilitation and conversion to condominiums of the apartments at Randolph and East Avenue is depicted in this undated photo. The availability of apartment buildings with two or more bedrooms, handsome woodwork, and other decorative details has turned these units into "starter" or retirement homes. The existence of an amenity, like these second floor porches, increases the desirability and value of such units.

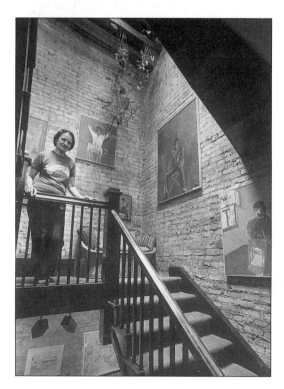

Another phenomenon that parallels the conversion of apartments to condominiums is the rehabilitation of a number of smaller buildings. In this example on Harrison Street, Helen Allen displays the art, furniture, and other furnishings that changed this building from a series of separate apartments into an interactive environment. Shared game rooms, laundries, and other niceties promote a sense of community among the tenants.

The Oak Park Arms, at Oak Park Avenue and Washington Boulevard, was the largest apartment hotel in the Village when completed in 1921. It contained all the luxuries of an upper-class establishment: parking, beauty salon, shops, and a restaurant. A modest addition was made in 1927 while the annex was added in 1928. Today, the building is a senior citizen residence with needed services on the premises, though the restaurant is open to outsiders.

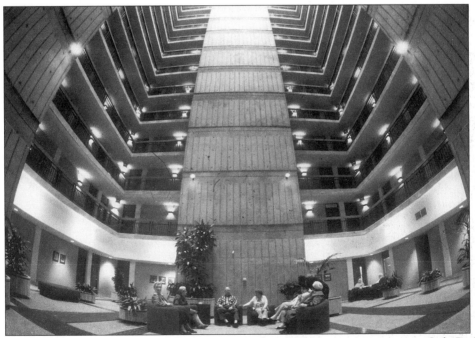

The Heritage House is one of five major residences for senior citizens in Oak Park, offering state of the art safety devices in each unit along with facilities for socializing and recreation. Opened in 1979, this building was a private development geared to moderate income residents of the community, though some of the other such residences attract a more affluent clientele.

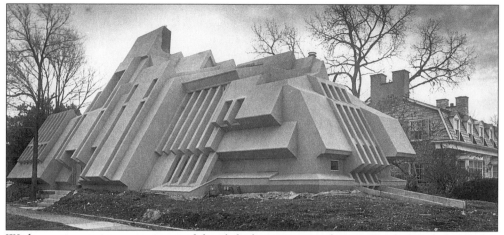

With an increasing awareness of fossil fuel wastage, architect Errol Kirsch built this passive solar house at Greenfield and Fair Oaks for his family between 1979 and 1981. Emphasizing insulation and energy efficiency with an equally unconventional flow of interior space and arrangement, this large home attracts curiosity and attention from residents and architectural tourists alike.

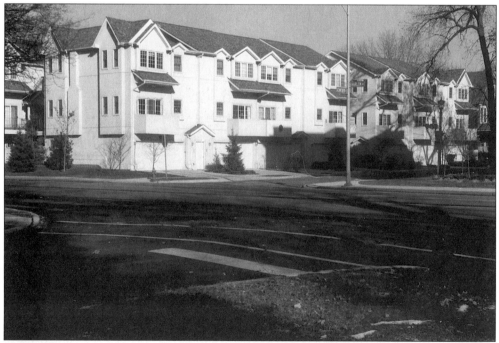

Oak Park's perimeter and arterial streets have long attracted multi-unit development. The trend continues at the start of the twenty-first century. These recently completed attached town houses on Harlem Avenue, like others on South Boulevard and throughout the Village, are the descendants of the row houses on Forest and Clinton that were erected a century earlier, both in their density and the verticality of their design. (Photo by author.)

Two

TRANSPORTATION

From the earliest years of settlement, the two communities that came to be Oak Park were continuously linked to Chicago and her various forms of public transportation. The incorporation of the Village in 1902 coincided with the viability of the automobile as a mode of transportation. The automobile impacted both transportation routes and population settlements as people no longer had to think about the proximity of their homes to fixed rail lines. Other concerns made themselves felt as the community grew and created its own ordinances, procedures, and zoning. Such early issues as the location and conditions for keeping horses and sidewalk responsibility gave way to concerns about automobile speed limits and parking. As traffic increased and more and more accidents occurred with automobiles at railroad and trolley crossings, changes in both laws and track elevation had to be considered.

Oak Park is still part of the major urban transportation systems, including the railroad, rapid transit lines, and a number of bus routes plying the major thoroughfares. The ease of getting to the city, outlying suburbs, and the community itself via public transportation, auto, or taxi, has kept the community viable and desirable as a place to live and work.

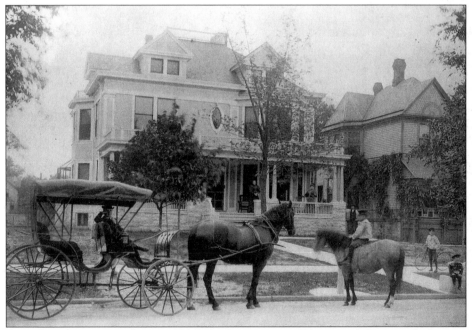

When this photo was taken in 1896, the horse was still king and those with the means to own one usually kept it in the small stables behind their large Victorian homes. Servants' quarters were in coach houses above the barns of the wealthy while feed was kept in the loft above the stable. The doors over some contemporary garages reveal the structure's early history as a barn.

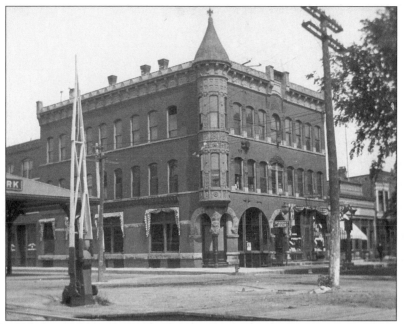

When the Dunlop brothers built the first bank in Oak Park, they chose a site adjacent to the rail line that came through Ridgeland and Oak Ridge. The commercial hub was the area bounded by Marion and Harlem Avenues, Lake Street and North Boulevard, and the baggage car that served as the first Oak Park station had been placed there in 1872. This view of 1903 shows the 1890s Chicago and North Western Station in the foreground.

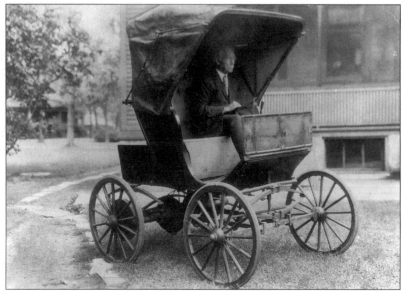

In the early days of the automobile, there were many competing small manufacturers in and around Illinois. It was by no means certain that one form of internal combustion engine would wipe out all the competitors. Charles E. Roberts, a local inventor and engineer and later a friend and supporter of Frank Lloyd Wright, sits in an electric car that he owned in 1897.

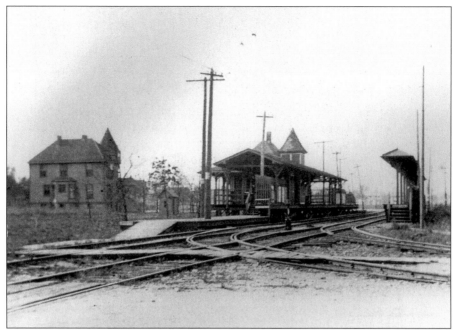

The various commuter lines at the turn of the twentieth century were not limited to running east and west. Pictured is the depot at Randolph and Lombard, just east of the point at which it turned South to 12th Street (Roosevelt Road). A century later, the site is a block-long wooded park referred to by neighborhood children as "Monkey Island."

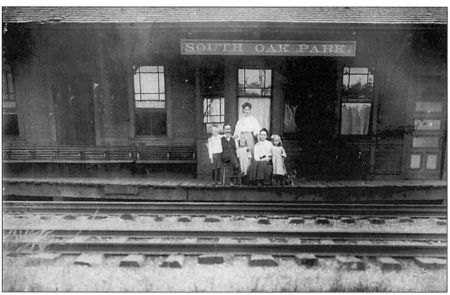

The commuter lines that still covered the Village in 1907 were at ground level, often with complex webs of wires overhead. Families like the one pictured at the South Oak Park Station had to be careful when trains or cars were coming, but there was no electrified rail at ground level. They could take the train to the Loop, the Des Plaines River, or places of amusement and recreation.

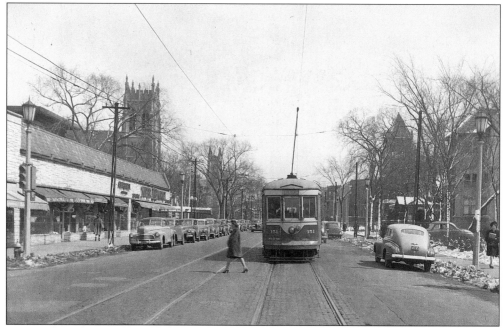

Automobiles were everywhere by the time this picture was taken in March 1947, yet the electric trolley still held sway on most of the main arteries of the Village. The newspapers of the day commented on the scarcity of parking. This shot of Lake Street shows tightly packed cars on the North side of the street lined with retail stores. (Photo courtesy of Downtown Oak Park.)

Although the automobile had won the day long before this photo was taken in the Winter of 1943-44, there were still horses in the community. This man uses a plow to clear sidewalks on the 1000 block of South Lyman Avenue. The Village's trucks were not able to plow the sidewalks and small motorized equipment had not yet become a viable alternative for the average homeowner.

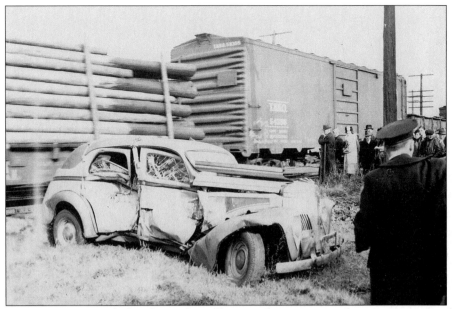

Having commuter and freight rail traffic on the same grade as streets used by automobiles and pedestrians became an increasing problem as the volume of automobile traffic grew. Accidents where a train hit a vehicle attempting to cross the tracks ahead of the long freight trains often resulted in fatalities. Disasters like this 1941 crash increased agitation for separating the two forms of traffic.

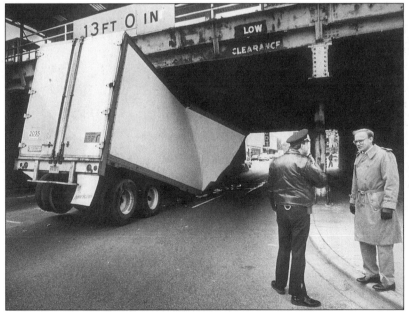

Raising both the C & NW Railroad around 1915 and the "El" to an embankment in the 1960s removed the threat of train/car accidents. But the increase in the size of trucks and repeated repaving of the only north/south artery open to commercial traffic from the Eisenhower Expressway made accidents like this one in 1989 a familiar sight on Harlem Avenue. Misjudgment and frustration produced the same results.

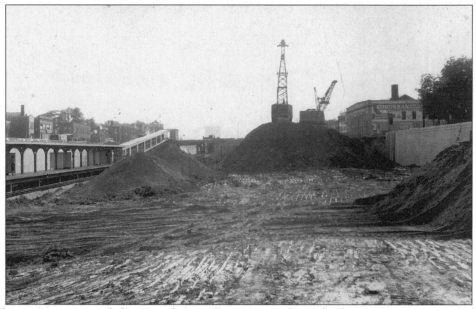

The construction of the Eisenhower Expressway through the Southern part of the Village in 1959 caused the removal of many homes, but the impact was weakened by local insistence that the road narrow from four to three lanes while passing through Oak Park. The central ramps are unique to Oak Park along the length of the road; they were negotiated by Village Officials to minimize the impact of the construction on the community.

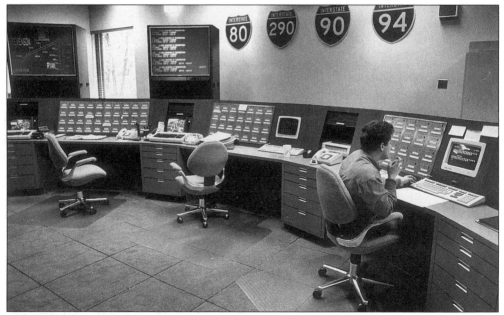

This little noticed Illinois Department of Transportation Traffic Center on Harrison Street, west of Ridgeland, overlooks the Eisenhower Expressway. Over 100 miles of the Chicago area interstate expressways are monitored at the screens and computers that make up the consoles in this large command center.

Shifting work and family patterns have created a situation where many apartment houses that once attracted young people and retirees relying on public transportation are being filled with car owners. Residential buildings constructed since the 1960s include parking for each unit, but those residing in older rental units and condo conversions must wait in line for parking in Village owned lots.

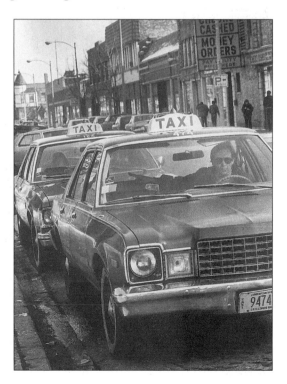

The public bus system provides service on the major arterial routes through and along the borders of the Village, but the local taxi company is preferred by many commuters as they get off the "El" or railroad. Seniors enjoy special fares that get them to stores, appointments, as well as religious and recreational activities. These cabs wait near the Marion Street IC Station at rush hour.

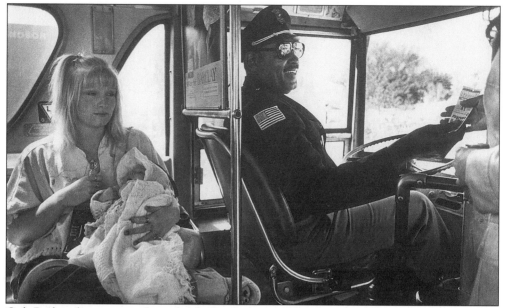

Oak Park is fortunate to have both the Congress Blue Line and the Lake Street Green Line El, the Union Pacific Railroad commuter line, CTA bus along Austin Boulevard, and the various Metra bus routes that now form PACE. As part of an attempt to build ridership, the then West Town Bus Company sponsored a contest to recognize driver friends. George Hamilton of Oak Park was one of the first winners in the mid–1980s.

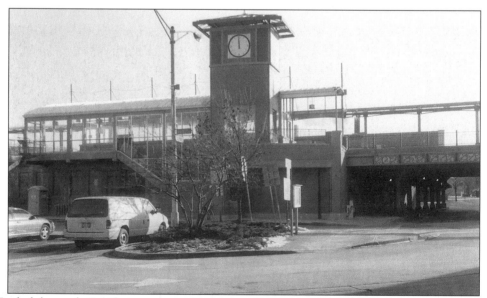

Fueled by a desire for new economic development and a goal of tying the array transportation systems together, a new intermodal transit station was built at Marion Street between North and South Boulevards in 1999. The clock tower is the symbol of the revitalized station as it stands at the heart of the traditional business downtown. The Village President, Barbara Furlong, started the clock at midnight of January 1, 2000. (Photo by author.)

Three
PUBLIC SERVICES

It is obviously an advantage to the citizens of Oak Park that so many of the services needed by the community are met by Village, Township, Park and School Districts that share a common boundary. It is also easier for the authorities to negotiate for other services provided by either federal agencies or public utilities that contract with the community or individuals. The Village provides police and fire services, as well as such standard municipal services as street paving, garbage and snow removal, water and sewer. Over time, it has also negotiated changing relationships with the utilities that provide light, heat, telecommunications, and other utilities. In the last quarter of the twentieth century, the Village Government also found itself more directly involved in issues of economic development than the traditional ones of providing easements, negotiating utility rates, and providing some other municipal services.

The overlap between various local taxing bodies create situations where there is either shared responsibility or direct support by one taxing body of the other. Examples are the way the Village government provides and pays for nurses and crossing guards for the schools and covers library employees under its medical fringe benefit program. In turn, the Park District has taken over the functions formerly administered by the Village Recreation Department. There is always a desire for more intergovernmental cooperation, though it often develops as the result of specific issues rather than through long range planning.

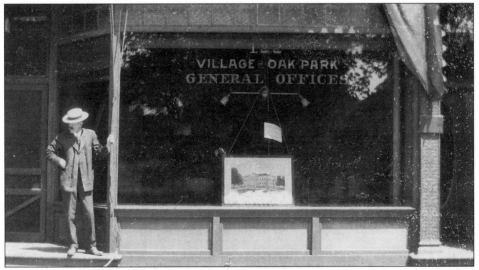

The Village of Oak Park General Office was first housed in a storefront at 122 North Oak Park Avenue when the community broke away from the Cicero Township. This 1902 photo was taken during the construction of the municipal building one block east, a move opposed by those citizens who wanted the building closer to the population center of the Village. Fire and police services were at other locations, and Board meetings were held at Scoville Institute.

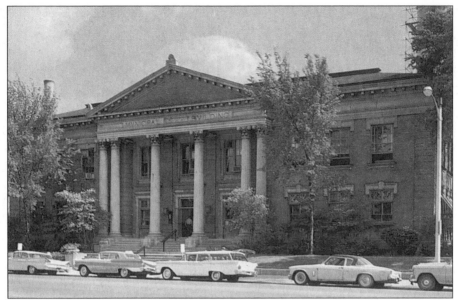

The Municipal Building at Lake and Euclid was designed by the firm of E.E. Roberts and was the official home of Village government from 1903 until 1975. The Classical building was built just west of the geographic center of town. It contained the police station and was adjacent to the main fire station. However, it was too small and inappropriate for contemporary functions and was replaced by the current Village Hall.

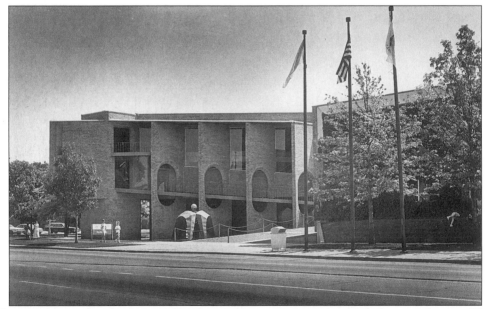

It was obvious by the late 1960s that Village government needed a new home. The Board took the bold step of building the new Village Hall in East Central Oak Park as a statement of commitment to those who feared that block by block resegregation would lead to the abandonment of Village Services for that part of town. Architect Harry Weese created an open plan, influenced by the Finnish architect Alvar Aalto, and with a courtyard derived from a renaissance palace. The building opened in 1975.

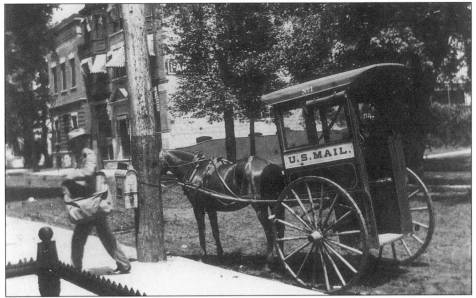

This undated photo illustrates mail delivery near the turn of the twentieth century, with one Captain A.A. Busett driving Horse and Buggy # 1 on his rounds. The mailbox on the pole dates back to the early 1890s when it was deemed impracticable for people to bring mail to the Post Office from around a community that was rapidly expanding to the east, north, and south.

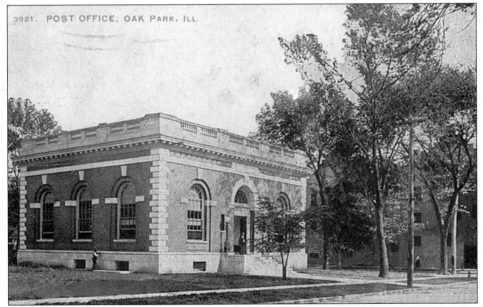

The first US Post Office built in Oak Park is depicted here in a 1914 postcard. Erected at the NE corner of Lake and Oak Park Avenue and open for business in 1906, the brick building complemented the Classical structure of the Municipal Building two blocks east. The fact that it was built more to the geographic than the population center indicated both a prediction of future growth and the solidarity of the site's supporters.

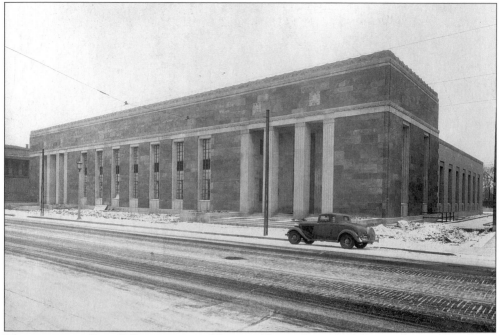

The new main Post Office is pictured here in December, 1935. It was designed by local architect Charles White and is a marvel of late Art Deco architecture. The decorations on the doors present the history of mail delivery in this country while the murals in the main lobby illustrate the history of America itself. Sensitive restoration earned the Postmaster an Oak Park Preservation Award in 1977.

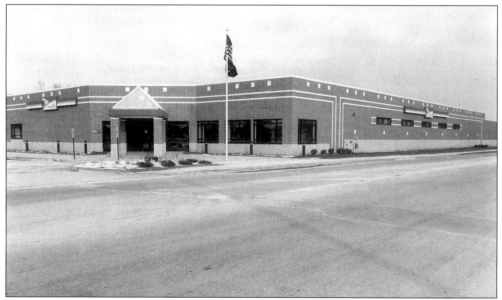

The branch Post Office that had served the south part of the Village was replaced by a new and larger facility in late 1999. Instead of the prior location in a row of shops on S. Oak Park Avenue, the new building has ample parking and sits on a large plot of land on Garfield along the south side of the Eisenhower Expressway.

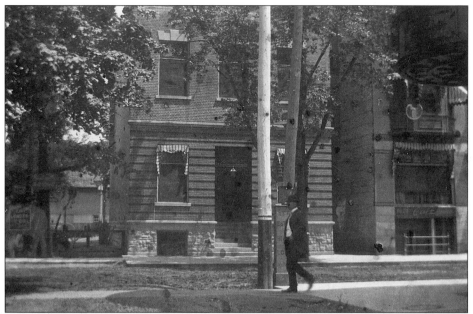

Telephones began to rival the postal service for local communications by 1900. With over 1000 telephones in personal and business use by that date, the Chicago Telephone Company could no longer function in rented headquarters nearby and needed their own building. The necessity resulted in the first Oak Park Telephone Exchange Building, pictured in the heart of the business district at 118 N. Marion in 1902.

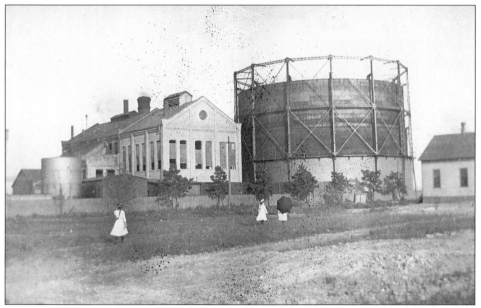

The Cicero Water, Gas, and Electric Light Company built this large capacity Gasworks Plant in 1893. Just South of Garfield at Lombard, the plant produced gas for Oak Park homes by burning coal. This undated photo shows the "tank" that identified the utility from some distance around; a tank which produced enough gas to supply the community from its opening through 1930 when the utility switched to natural gas.

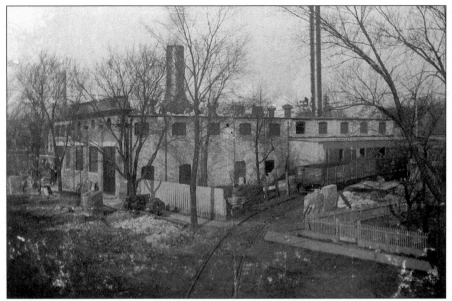

The Yaryan Light and Heating plant was built on the northwest corner of North Boulevard and Euclid in 1901, supplying heat to much of the new Village. The facility, pictured here in 1902, supplied hot water heat at an even temperature through its service area of East to Harlem and Chicago to Madison, making a boiler and coal or gas furnace unnecessary. The company ceased operations in 1958.

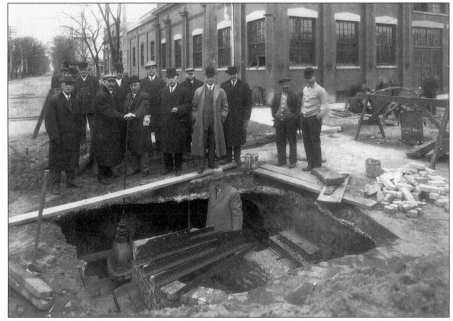

Lake Michigan water was first brought through Oak Park's water mains in 1912. The location of this photograph of the same date is at North and Euclid. The merger of the existing Oak Park water system with the Public Service Company of Northern Illinois removed both the dependence on the utility and the threat of insufficient pressure for fighting fires. Today, all the Village water comes from Lake Michigan.

Street paving only began in 1889 having already caused public criticism as being both financially extravagant and a threat to the rural character of the community. Most of the streets were paved or bricked, often with cedar blocks by 1903. Shown above is one of the earliest cement sidewalks being laid in front of the Marion Street home of E.W. Hoard shown in the foreground leaning on crutch. The first alleys were paved in 1910.

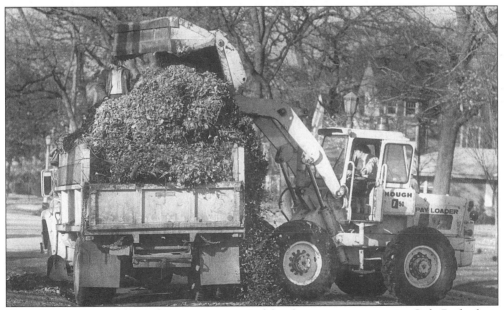

Care for the streets have been accompanied by forestry programs in Oak Park that, since the 1960s, have devoted many resources to the removal of diseased Elm trees and their replacement. The Village has taken an aggressive stance, immediately removing diseased trees and replacing them under a citizen Forestry Commission supported plan that seeks to avoid future disasters by planting a variety of trees on the parkways.

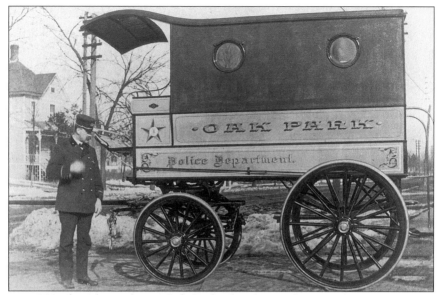

Taken in 1902, this photo shows Oak Park's first horse-drawn police patrol wagon and ambulance, probably the one that was purchased with the $500 collected by Lt. John Schwass. By the time the Village government was established, the small force patrolled the major streets and was able to time and arrest bicycle riders who exceeded the 8 mph speed limit on their Sunday outings.

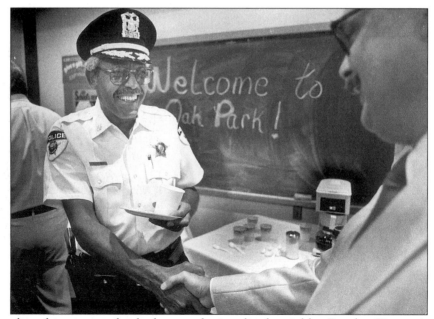

The police force grew slowly but professionalized quickly. By the Depression, an advanced communication system, fingerprint records, and a juvenile officer were all part of the operation. Nepotism was still common until the mid 1960s when the Village sought to raise educational standards and to increase the diversity of the force. Edward Buckney was sworn in as the first African-American Deputy Chief in 1988.

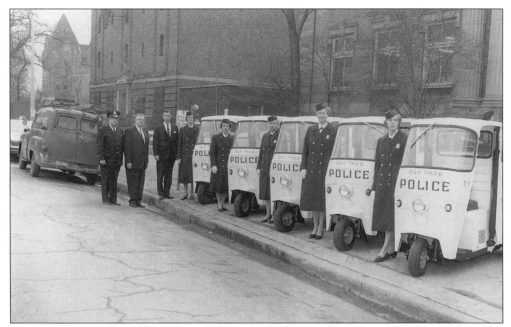

The increased role of the automobile in both the residential and business life of the community created severe and complex parking problems. Hoping to minimize the impact of illegal all-day commuter parkers who were taking public transportation downtown or those who were ignoring time limits at meters in the Village's business areas, the Village initiated the Meter Maid program. This photo was taken at the Municipal Building in 1966.

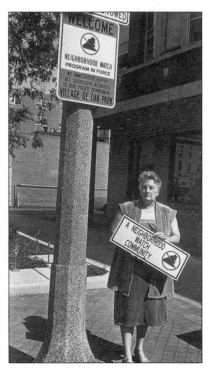

As increased crime and the mobility of criminals created a demand for more public safety, programs like Operation Whistle-Stop, the Collaborative Process, and the Neighborhood Watch were developed. Such programs involved the citizenry in knowing their neighbors, reducing criminal opportunities, and promoting participation in community police activities. Susan Helfer, the founder of Neighborhood Watch program, is shown here standing near one of the new program signs in 1986.

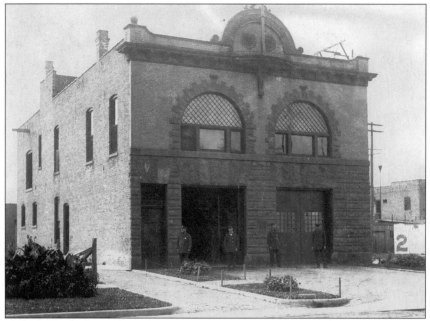

This 1900 photo shows the old Cicero Volunteer Fire Company No. Two, an operation staffed by local merchants and neighbors, at the southeast corner of Lake and Lombard. The facility was transferred to the Village after the separation in 1902. The first chemical engine was purchased in 1906. The station was closed and its equipment was divided between the Central Station and the new Augusta Street Station in 1916.

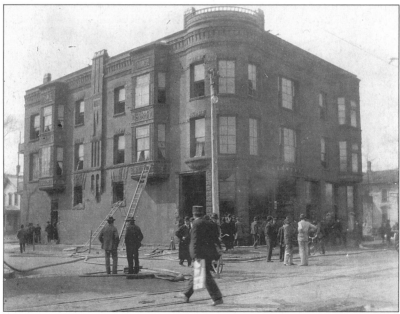

Major fires were still a problem when this grocery, one of the several businesses in the Niles building at Wisconsin and South Boulevard, caught fire in 1905. This blaze in a major commercial building gave the fledgling operation at the Municipal Building a chance to show their worth.

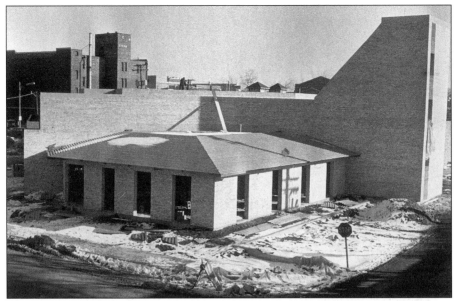

A modern Central Firehouse became part of the plans to demolish the old Municipal Building and convert the property into another use by 1975, but the new fire station was not built until the end of the decade. Still near the center of the Village, the fire department had the firefighters trained as paramedics and faced another form of change by preparing for the possibility of women as firefighters (now a reality).

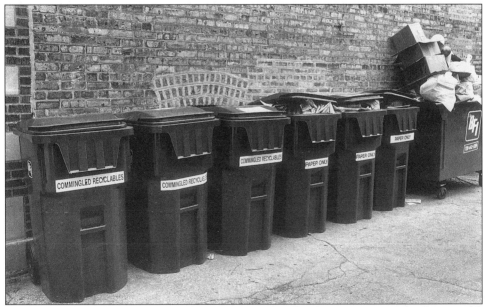

Just as the fire department took on new roles by becoming involved in public education, the sanitation department began to shift from simple garbage pickup towards the development of recycling programs. Increased ecological awareness added to the skyrocketing costs of landfills created a great need for recycling. Private residences and small flats participate in the Village Program while larger buildings make their own arrangements, as seen in this 1994 photo.

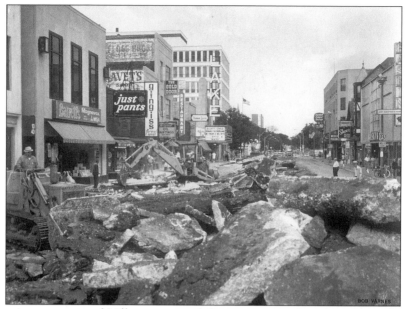

BOB VARNES

Street paving was part of Village responsibilities since its founding, but taking out a street to develop a pedestrian mall was one of the new programs undertaken by the community in the early 1970s. This 1975 photo shows the heavy equipment tearing up the concrete in the heart of Downtown. The experiment failed and, with pressure from the Downtown Oak Park business community, the mall reverted to an automobile oriented street in 1989.

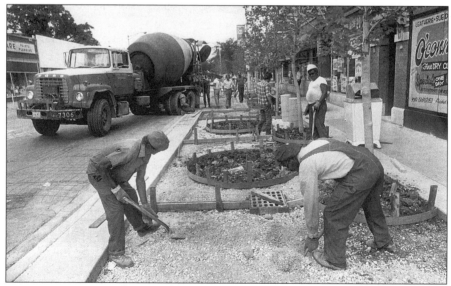

Routine maintenance of navigable streets, sidewalks, and alleys are not the only function of public works paving projects at the end of the twentieth century. As seen in this photo taken on Chicago Avenue near Austin Boulevard, community beautification projects have been taken beyond basic construction, especially at the gateways to the Village. Trees, benches, and decorative bus shelters have become part of the Village's streetscape, often utilizing Federal Block Grant Funds.

Four

COMMERCE

The original settlers of Oak Ridge produced much of their own food, meeting their needs for consumer goods in downtown Chicago. However, a communal change from agriculture to residential along with a population surge after the Chicago Fire created the need for consumer goods. This need encouraged retail establishments, light industry, and privately owned utilities. Lake and Harlem became the main transportation hub for the commercial downtown. The local and hinterland population could soon purchase whatever they needed near the Lake and Marion junction. Oak Park Avenue and Lake Street became a second retail center with some stores in the more remote and sparsely settled parts of town. North Avenue and Roosevelt Road grew more slowly, but Madison Street developed its own identity as the automobile became the dominate form of transportation by the end of World War II. Oak Park Avenue and Garfield and Harrison near Ridgeland became regional centers for the purchase of commodities and access to services for local residents.

By the end of World War II, the community had reached its maximum growth. Department stores were the dominant commercial form downtown as Marshall Field and Co., The Fair (later, Montgomery Ward), and more specialized chains like Lyttons and Baskins were supplemented by furriers, appliance dealers, and specialty shops. Food stores, florists, hardware stores and repair shops continued as the focus of the neighborhood shopping areas while the remaining farms, wholesalers of building supplies, and light industry, disappeared. Oak Park lost all its major anchors to suburban malls and retail consolidation. Today, community leaders work in partnership with Oak Park Development Corporation to diversify and strengthen its tax base.

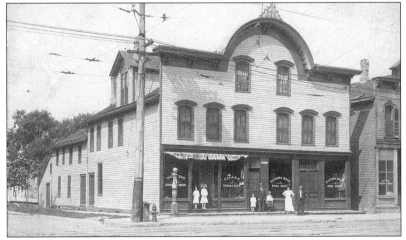

Lake Street at Harlem, pictured above around 1910, was the main transportation and commercial hub of Oak Ridge and, due mostly to its proximity to the railroad, the train, and trolley lines, remained so for the new Village of Oak Park. The numbering of east/west buildings began at Harlem and many of the ads for the old businesses show those addresses. The building house a barber shop, a tobacconist, and a pool hall, and apartments on the upper floors.

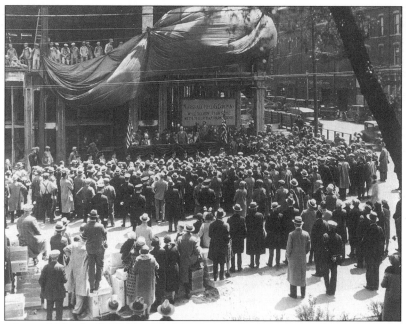

The opening of Marshall Field and Company's first two stores in the suburbs (the Evanston store opened and closed the same days as the one in Oak Park) was an important sign of the economic importance of suburban downtowns. This 1929 photo depicts commercial and civic leaders gathered for the cornerstone ceremony on May 21 with the workmen on the ledge above them. (Photo courtesy of Downtown Oak Park.)

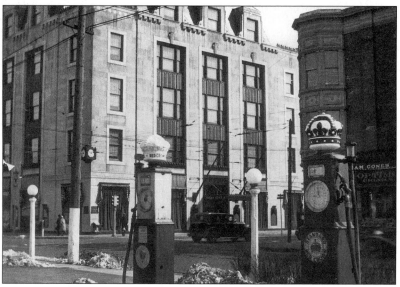

The site of the Field's building soon after it opened is the same as in the view above. Notice the new building surrounded by an old walk-up office and commercial building to the south and the gas pumps of a service station to the southwest. The overhead lines and the tracks of the trolleys indicate a close relationship between commerce and public transportation.

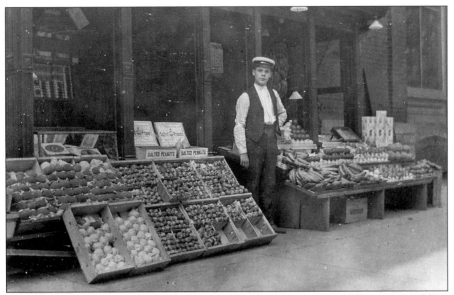

The daily purchase of fresh produce was very important to Villagers. Middle class housewives considered it desirable to shop for the fruit, vegetables and meat for that day's dinner, if at all possible. Here, the brother-in-law of Gus Cutsuvitis stands in front of the family owned fruit stand in 1902. The fruit stand was a fixture on the West side of Marion at Lake starting in 1896.

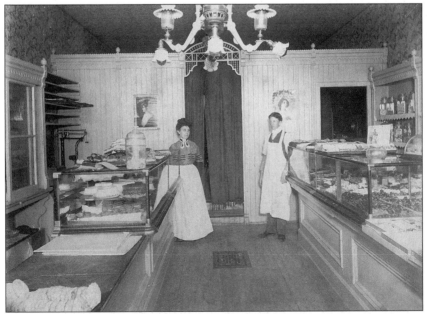

Around the corner from the fruit stand, on Lake between Marion and Harlem, was the Oetgen Bakery, pictured here around 1903. Such retail establishments for food coexisted with haberdasheries, hardware stores, and the businesses already depicted. The place to buy fresh bread, as well as pies and tarts for dessert and special cakes for special events and occasions, is one of the few forms of small business that still survives a century later.

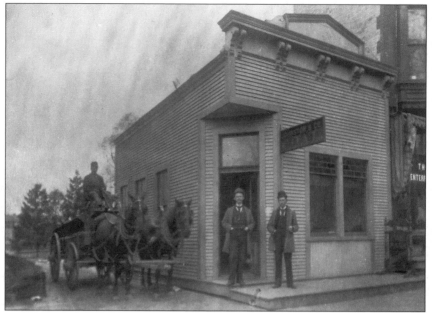

This 1892 photo shows the Johnston and Company coal office, at Marian just North of Lake. The increasing growth of the community made the location desirable to retail merchandise shopkeepers, and businesses that required substantial storage soon moved to the fringes of the community. The coal office was replaced by a brick building that was leased to the post office in 1894.

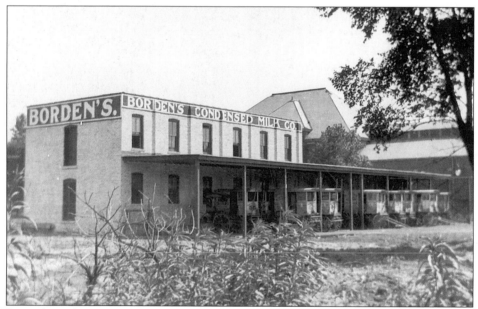

When this photo was taken in 1903, small manufactories and suppliers of such products as milk could still be found within the boundaries of the community. This two story building served as headquarters for the local branch of the Borden Milk Company. To the lower right of the main building are the stables for the horses and wagons that delivered the milk throughout the community.

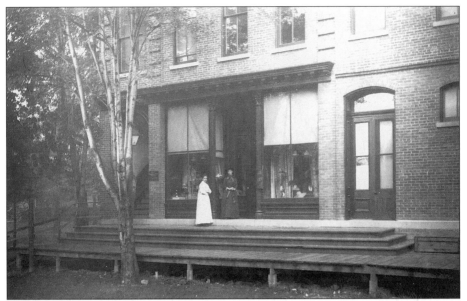

The above photo of Flora Gill and two assistants in front of her millinery store on Marion near Lake was taken in 1884. Not only does this image provide important visual documentation of a woman-owned business at that date, but we also get a clearer view of the wooden sidewalk along and above the unpaved major street. The Presbyterian Church rented space for their services on the second floor of the building.

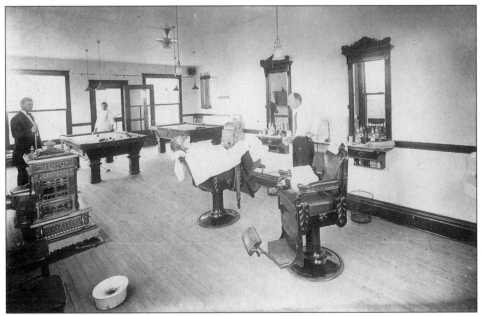

This end of the nineteenth century photo of a barbershop is a reminder of a more relaxed, less hurried era. Not only could the customers awaiting their turn for a shave and a haircut shoot pool, but they could also enjoy a cigar in front of the stove and avail themselves of the spittoons as needed. Such establishments like this barber shop at Lake near Harlem served a social and a service function for their clients.

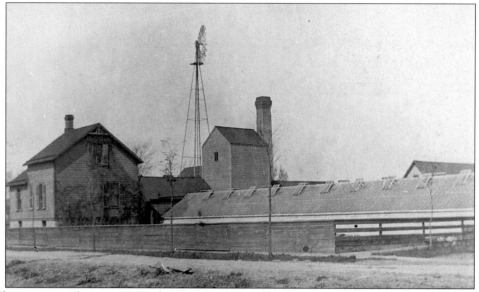

This image, taken in 1903, depicts the Schneider Home and greenhouses at Harlem and what is today Schneider Street. The family business was at that location for many years, surviving until 1930. The family trucked fruits, vegetables, and decorative plants to locations in the Village and neighboring communities, eventually functioning as a retail operation in the downtown. In later years, the business was known as Lange's.

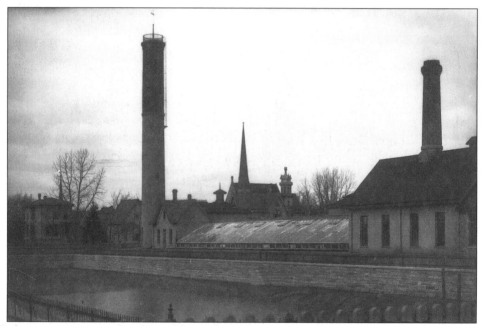

Today, water is considered a public utility. However, at the time this photo was taken in 1887, the new waterworks at North Boulevard and Oak Park Avenue were recently converted from a private business to a corporation by James Scoville. The great landowner started with a pool on his property which he converted to a reservoir and then added piping and pumps to supply water to local businesses.

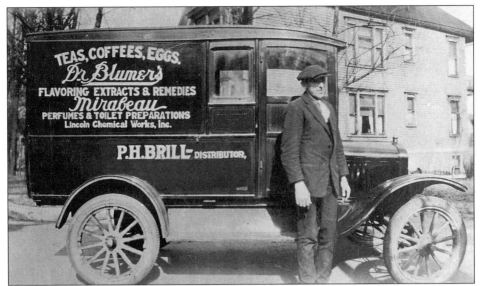

Motorized vehicles had pretty much replaced the horse and wagon by 1918 when firms like P.H. Brill were making the rounds through Oak Park, servicing the several small businesses that stocked the various products they distributed. Note the range of products, from staples like coffee and eggs to toiletries and various herbal and patent remedies for whatever might ail the public. Trucks were small and deliveries were daily or weekly.

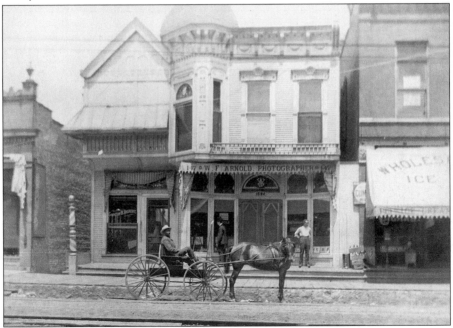

Lake Street between Harlem and Forest Avenues was a haven for many multi-use buildings when this photo was taken in 1903. In front of Arnold's photography studio is L.E. Bailey, a successful and popular ice merchant who supplied a mostly commercial trade. W.F. Arnold was the third photographer to run the studio on the site; Westphal Studio had been the first, and then Thayer sold it to Arnold.

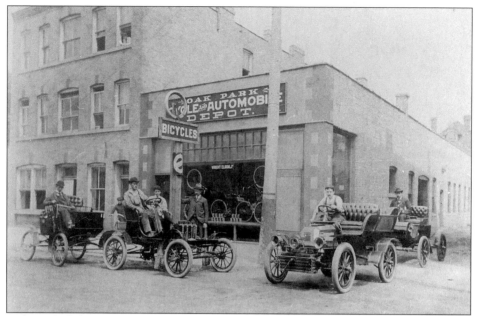

Another of Philander Barclay's many photos of the business community in 1903 shows the Oak Park Bicycle and Automobile Depot. The success of the car seemed assured by then, but cars were still out of reach for many residents. In addition, sportsmen and those too young to drive supported the several bicycle shops in the Village at that time. Cars were ordered and not much room was taken by the average showroom.

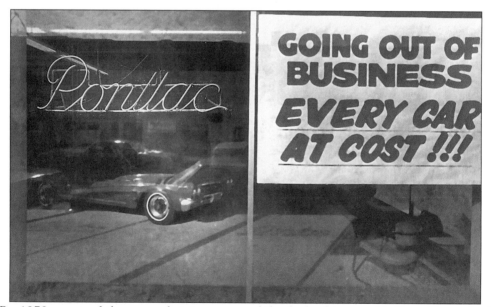

By 1979, most of the once thriving automobile dealerships on Madison Street had already left and more on Lake and Roosevelt were to follow. The high cost of real estate in the Village drove out the dealers who needed enough land for the large inventory required for a public that would no longer order a car and wait. Dealers like Clarke Pontiac moved to exurban communities where land was plentiful and cheap.

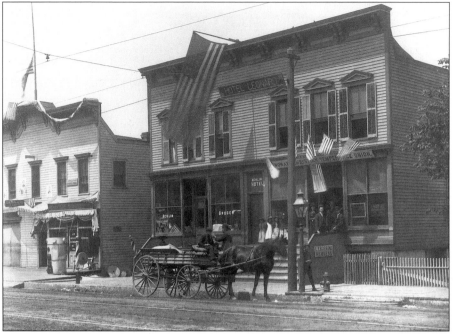

This 1892 photo illustrates another of the small buildings on Lake Street that served many concurrent functions. The Hotel Leonard consisted of a few rooms on the second floor, Berlin's grocery was on the ground floor left, and right was then the headquarters of the W.C.T.U. On the floor below were John Pagers' barber shop to the left and the harness shop of Edward "Father" Robbins on the right.

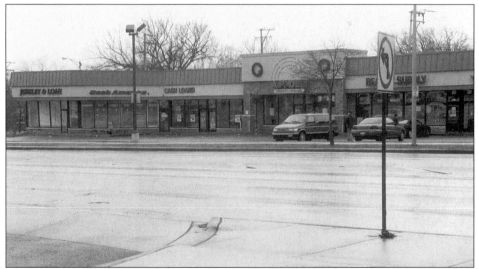

This photo of the strip mall on the corner of Ridgeland and North was taken in 2000. The few homes that were on the prairie at this point atop the continental divide were replaced by a secondary shopping street that flourished after World War II and lost ground to suburban shopping malls in the early 1980s. Such strip malls became the only form that most developers would bring to the shallow parcels of land in the last decade. (Photo by author.)

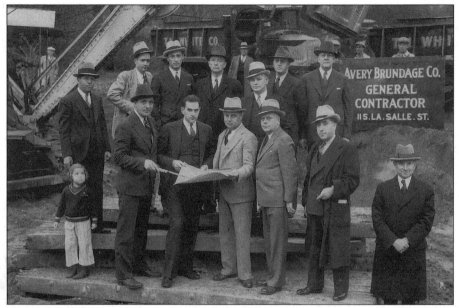

The ground breaking ceremony for the Lake Theater in 1936 was one of the few bits of economic development in downtown Oak Park at the height of the Depression. Going to the talkies was the entertainment of choice for people whose discretionary dollars were in short supply. Today, the Lake's original theater has been subdivided. Two adjacent buildings have been incorporated into what is now an eight theater complex. (Photo courtesy of Downtown Oak Park.)

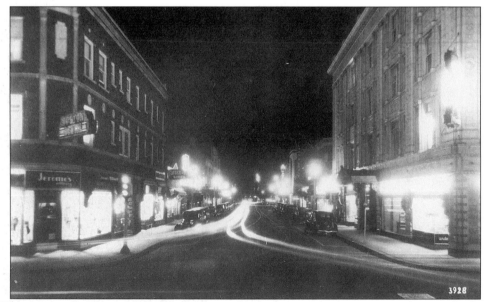

This rare night photo of the busy corner of Marion at Lake Street was taken in the late 1930s. Notice the eclectic array of businesses and the pervasiveness of the automobile. The decorative elements of the buildings are intact as the desire to modernize had not yet resulted in tearing out of windows and the covering the upper floors with synthetic skins that later concealed the windows throughout the downtown.

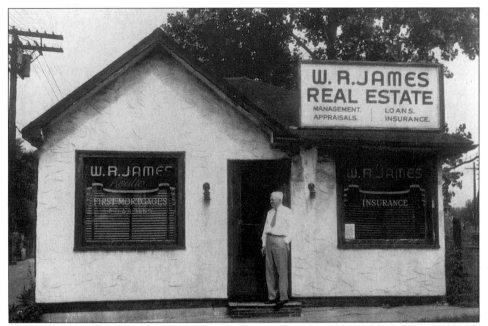

The original real estate office of John E. James was built at 914 Gunderson. The office was enlarged by his son, W.R. James, after taking over the business in 1919. When it was displaced by the construction of the then Congress (now Eisenhower) Expressway, the firm moved to Madison Street. The founder's grandson, Bob James, proceeded to move the office to Oak Park Avenue. The firm merged into a larger one in late 1999.

Bank mergers, buy outs, and closings have been part of life in Oak Park for the last two decades. Here, a patron reads a 1990 notice on the front door of Great American Federal Savings and Loan, telling of a takeover by the Federal Government. Most of the local banks closed or were absorbed by larger chains, with a loss of both local control and community involvement. The faculty is now in use by Community Bank.

The Sea Garden Restaurant replaced what had been Neptune Cove in the early 1980s. The location at the southwest corner of Harrison and Ridgeland was far from the major retail and commercial centers of the community and struggled under several owners until a fire ended its brief existence.

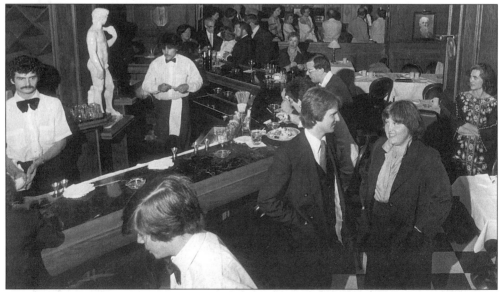

The opening of Philander's Restaurant in 1979 was the start of a new era in Oak Park. Liquor sales and licenses were still a novelty in the community when Dennis Murphy obtained the first license to have a full service bar in conjunction with an upscale restaurant. The business flourished. Today, there are now almost 75 restaurants throughout the Village, from fast food to elegant dining establishments, some with bars and some serving wine and beer at the table.

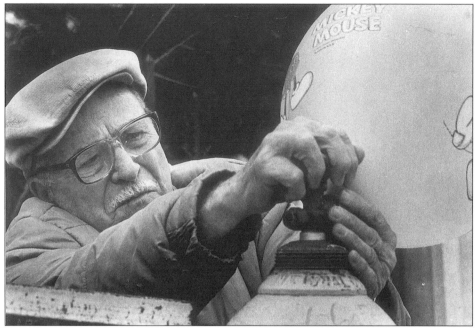

The Balloon Man, pictured here in 1986, was the affectionate nickname given by the children of Oak Park for the quiet and gentle man who became a fixture on the northwest corner of Chicago at Oak Park. His tanks of air and colorful balloons stood next to the iron railings of the Jesuit residence on that corner. It was a rare parent who could resist the pleadings of children to stop and purchase his wares.

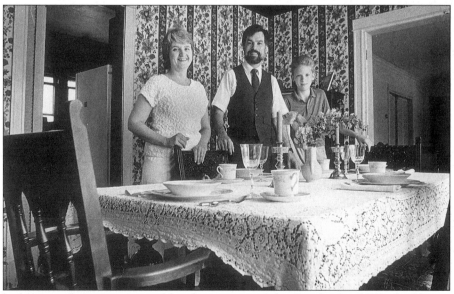

With the rise of tourism spurred by the success of the Frank Lloyd Wright Home and Studio, the need for various forms of visitor housing created a modest Bed and Breakfast industry in Oak Park. This 1988 photo shows the Newitt family in the dining room of their home on South Humphrey Avenue where they offered home cooked breakfasts and an intimate setting for special guests.

The malling of Oak Park's original downtown proved to be popular with pedestrians but despised by merchants. Its days were numbered when this photo was taken in 1982. Although Lake Street was once again open to vehicular traffic, one block of Marion from Lake to North Boulevard still maintained its benches and low berms, serving as a place for public events and those who like to watch them.

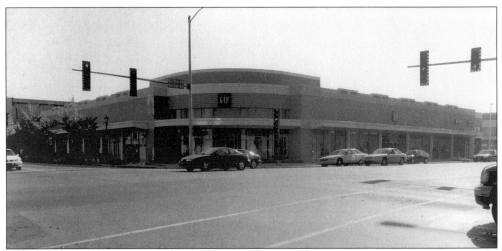

This recent photo shows the new shopping center on the southeast corner of Lake and Harlem. With several "anchors," a group of specialty stores, and on-site parking, this development bridges the gap between traditional downtown and the suburban mall. The lure of economic development for the community added to the fear of giving too much control and excessive developer incentives produced a lively and continuing debate. (Photo by author.)

Five

CIVIC LIFE

The early history of the community is tangled with its identity as part of the Proviso Township and, after February 1867, as part of the Cicero Township. Many in Oak Ridge and Ridgeland wanted a separate community, but there was no enabling legislation approved by the state legislature. After an unsuccessful attempt to carve out several new towns in 1895 and a court ruling that an 1898 attempt was unconstitutional, both Berwyn and Oak Park were separated from Cicero in the landslide referendum of November 5, 1901. The People's Independent Party, the winning political organization in the first election of 1901, espoused a principle that each of the eight precincts of the Village should have an elected representative, either the President, the Clerk, or one of the six Trustees. This policy was maintained for some years, but faded away after World War II.

The fact that the Village, Township, Park District, Library Board, and the Elementary School District have been coterminous since the separation of the Elementary and High School Districts in 1899, has put Oak Park in a position enjoyed by very few suburban communities. Except for the High School District 200 that is shared with River Forest, the Village has been able to maximize its decision making potential under home rule powers. The community has always been able to resolve its issues internally and has thrived, achieving national recognition for accomplishment and innovation in spite of issues that created controversy and disputes between neighbors.

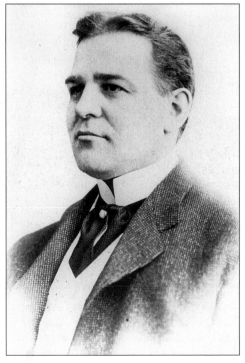

Allen S. Ray took office as the first President of the Village in 1902. It soon became the practice to emulate the unwritten rule of the American presidency not to serve more than two consecutive terms. The President and Trustees serve the same function as a mayor and city council, but the presidency has changed from an administrative position to a legislative one since the approval of a city manager form of government in the 1950s.

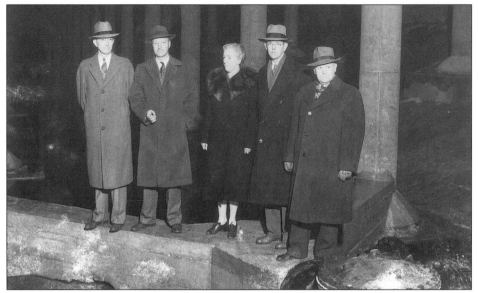

While the Presidents tended to limit their service to two terms, the elected Trustees were often reelected for longer periods of service. Dorothy C. Kerr, the first — and for a long time the only—woman Trustee took office in 1927. She appears in this 1941 photo surveying the municipal reservoir under the Stevenson playground at Lombard and Lake. Kerr held office until 1945, an unusual record for this community.

By the early 1950s, many Oak Parkers were dissatisfied with the existing patronage system and the way local government was operating. A group of citizens pushed for a referendum introducing a Village Manager form of government where a hired administrator selected staff, free of interference by the policy setting Board of Trustees. Pictured is an ad for the slate fielded by the victorious supporters of change in 1953.

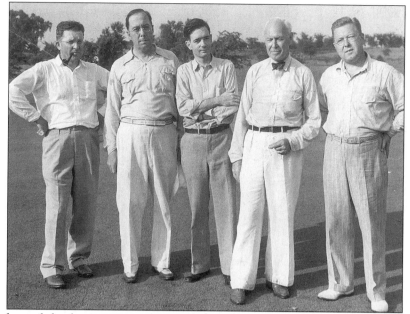

The leaders of the business community have always been an important part of local civic life, especially in those years when there were few corporate chains and most businesses were locally owned. The men who led the Chamber of Commerce probably decided as much at such golf outings as the one pictured in July of 1938 as they did at official Chamber meetings. (Photo courtesy of OPRF Chamber of Commerce.)

The annual Oak Park/River Forest Chamber of Commerce even had "high school days of the 50s" as the its theme in 1999. The dance line is led by Executive Director Loretta Daly, who serves an organization that is more diverse and broadly based than ever before. However, it also has more representatives of corporate owned businesses as well as many developers and owners of major businesses who no longer live in the community. (Photo courtesy of OPRF Chamber of Commerce.)

As part of the same challenges of the status quo that prompted Vatican II, the Civil Rights Movement, and various protests and marches, the Peace Movement certainly had its advocates in Oak Park. Pictured here are two anti-war leaders: Lenin Pellegrino, a local physician and civil rights activist, and Father Edward McKenna, one of the clergy who spoke out in support of this cause.

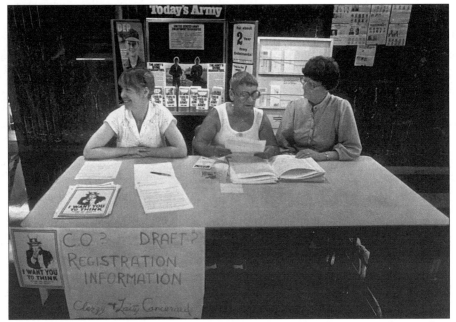

The activism of the late 1960s and early 70s was not only seen in marches and sit-ins, but also in the day-to-day activities sponsored by Clergy and Laity Concerned. Pictured are activists who staffed booths in the library, the post office, and other locations, distributing material on the possibility of being a registered conscientious objector rather than serving in the military.

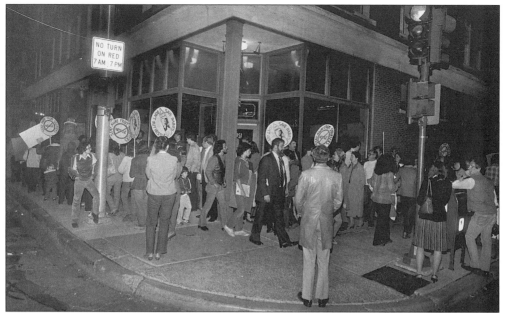

With the rise of corporate chains and conglomeration of businesses apparent in the 1970s, activism was as often against the practices of a parent company as those of a local business. These citizens are picketing the Cheese Cellar (now JB Wineberie) at Lake and Oak Park Avenue in 1982, protesting Nestle's policy of marketing baby formula to poor Africans who substitute mother's milk for a product that might be mixed in contaminated water.

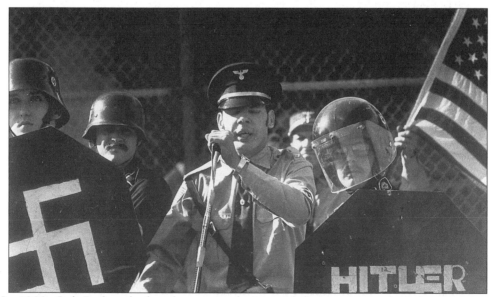

In 1980, Oak Parkers had to face an explosive and divisive issue when the American Nazi Party requested a permit for a demonstration in Scoville Park. The Village Board voted unanimously in favor of the permit, with the President and individual Trustees noting their total disagreement with the group's values, stressing the importance of free speech no matter how hateful the message of the speaker. The turnout was small.

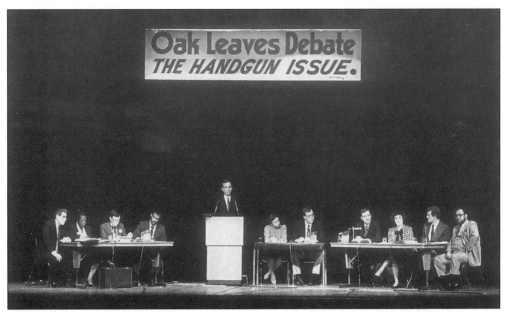

The ownership and sale of handguns in Oak Park had been an increasingly emotional issue through the first half of the 1980s. The Village Board finally forbade both the sale with firearms and ownership of handguns except under very narrow conditions. Victims of gun violence, lawyers, civil libertarians, and the police all took sides. Pictured is a 1985 debate before a non-binding referendum that eventually sustained the Board position.

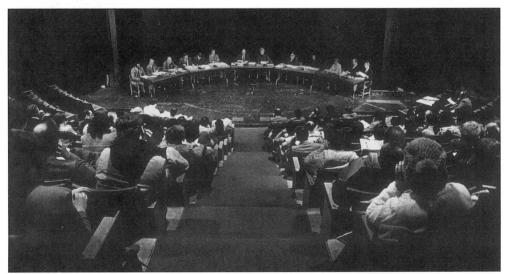

Another emotional issue that pitted neighbor against neighbor was the revelation that Reinholdt Kule, a longtime maintenance worker at OPRF High School, had lied to immigration authorities in order to conceal his career as concentration camp guard during the Nazi era. Before he was found guilty and deported, District 200 Board and administrators pictured here in 1984 discussed whether his earlier activities impacted on his keeping his job.

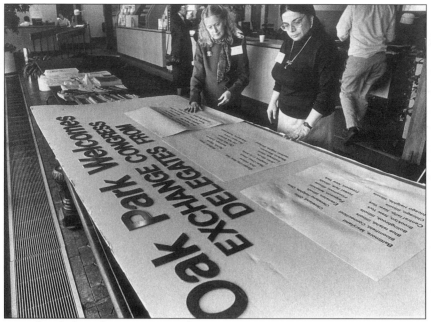

Citizens realized that they were not alone in striving to maintain economic viability while enhancing life in a diversified community, and organized a series of forums for similar communities from around the country. Pictured at the 1986 Exchange Congress are Oak Park Housing Center founder, Bobbie Raymond (left) and a staff member of the Community Relations Division of the Village government, Sandra Sokol.

Concurrent with the development of the Exchange Congresses, there were both official and ad hoc attempts to develop exchange programs in the 1980s. In addition to cultural and youth programs, visitors from emerging democracies and those undergoing rapid economic change came to meet with elected officials and civic leaders. They came from Africa, Asia, and Latin America as well, but this 1987 photo shows some of the many Russian visitors at Village Hall.

The Village election of April 1981 was typical in that the winning slate was supported by the Village Manager Association. What was unprecedented, however, was the election of both the first woman President, Sara Bode (on platform), and the first African-American, Percy Slaughter (below Bode).as a Village Trustee. Bode had just completed a term on the Village Board, but none of the Trustees had previously served in an elected capacity.

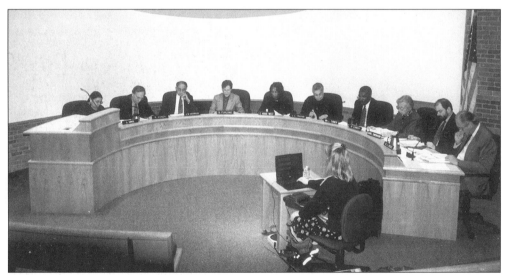

The current Village Board is the most diverse in Oak Park's history. With a woman President, a female majority serving on the Board, two African-Americans, and the first openly gay Trustee, the reality of Oak Park has finally been represented. Significantly, the three Trustees who were elected in 1997 included the two African-Americans, and they were unopposed for their seats. (Photo courtesy of Jim Budrick.)

Six

CULTURE

The cultural life of the community presents continuity and change as fully as any aspect of the evolution of Oak Park. There has been an interest in music, art, theater, literature, and other cultural manifestations since the earliest days of settlement. Some of the old organizations and institutions remain as others have died out and been replaced. Over the years, Oak Park has witnessed first hand the development of new forms of music and art, new ways of expression, and new publics. There have been changes in each media. Drama, for example, has evolved from exclusively live theatrical performance, through movies, into television, and back to live performances in community and outdoor theater. In the field of music, live concerts have been largely replaced by recordings, radio broadcasts, and beyond, though live performances are again in vogue. Public sculpture and institutional murals were supplemented by professional and amateur artists, and later by new forms of public art that brought professionals and average citizens working together to beautify the community.

Changing family and employment patterns have also affected cultural life, as has the increasing diversity of the community. While the affluent and middle class women's careers were limited to family and home, they would often join organizations devoted to exploring and expanding the arts. As they joined the business and professional work force in the last few decades, they were less likely to participate in literary and other daytime discussion groups. In turn, many creative people have settled in Oak Park in recent years. There are now more art galleries and music performances, more professional artists, musicians, writers and poets than in the era of Hemingway and Burroughs.

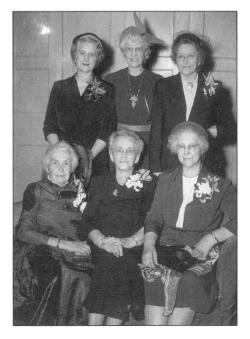

Nineteenth Century Women's Club, founded in 1891, is the private cultural organization with the longest history. It has offered two lectures every Monday for decades. Longtime member May Estelle Cook, at the lower left in this 1951 60th anniversary photo, was a charter member who also started the Community Lectures and served as a member of the Scoville Institute Board (later the OPPL) for close to fifty years.

Literature has always been an important part of Oak Park cultural life, with Ernest Hemingway and Edgar Rice Burroughs as her best known authors. Today, such women writers as Oak Park born novelist Carol Shields and Harriet Robinet, the author of several acclaimed books for children, have achieved national reputations as well. Robinet is pictured at a 1998 reading and book signing at a local bookstore, Centuries and Sleuths. (Photo courtesy of Centuries and Sleuths.)

Literary and book clubs have been part of Oak Park since at least 1884 when the Ladies Literary Society officially became the Augusta Club. The Traveler's Club, the Colonial Club, and the Lowell Club were also all founded before 1900. Both formal and informal organizations dedicated to the discussion of literature still abound. The Dog Tray group is typical of those that meet in member's home monthly. (Photo by author.)

Oak Park native Doris Humphrey was an important interpreter of modern dance. An ambitious young woman, she began offering dance classes for children, adolescents, and adults at the age of 18. Before leaving for New York, Humphrey taught at Unity House, at private homes, and wherever she could get a class together. She is pictured here as Titania in *A Midsummer Night's Dream*. (Photo courtesy of Academy of Movement and Music.)

The Academy of Movement and Music carries on the Humphrey tradition, and more, with a wide variety of classes in part of the old Bishop Quarter buildings that Academy founder Stephanie Clemens' converted to a school in 1983. One of her young dancers, Hillary Von der Weele, is shown here as she puts on her dancing shoes for a class. (Photo courtesy of A. Bradley.)

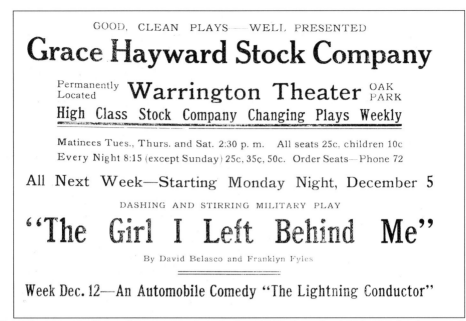

The Warrington Opera House was founded in 1902, but the 1500 seat facility couldn't survive with such a limited focus. It began to stage a broader range of theatrical events such as these advertised 1910 performances of popular plays. Local performers and stock companies, as well as various musical organizations, made intermittent use of the facility until 1930; it then changed hands and was later converted into a banquet hall and retail stores.

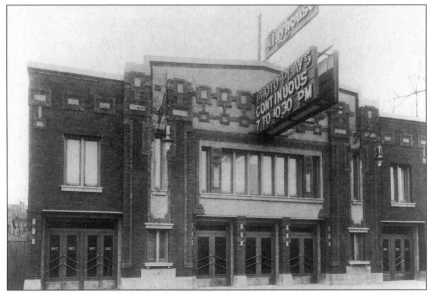

The Playhouse, on South Boulevard between Marion and Maple, was the first local building intended for use as a movie theater when it was erected c. 1912. This undated photo displays show times as a longtime part of movie culture. Similar theaters were built in the next several years, ending with the new Lake Theater in 1936. This old building still stands, now serving retail and office functions.

Parks and playgrounds have been the focal point of much of the outdoor theater and amateur productions throughout the history of Oak Park. This undated photo illustrates a "Pirate Dance" being staged at the little grotto that was a favorite gathering spot at Stevenson Playground. (Photo courtesy of Park District of Oak Park.)

This tableau is a part of a June festival at the Stevenson Playground in 1941. Such festivals, with painted backdrops, dancers, song, and skits, have long been a tradition in the community. The patriotic speeches of earlier days were supplemented by these more secular and imaginative programs. (Photo courtesy of Park District of Oak Park.)

The Oak Park Festival Theatre has been performing a different play by Shakespeare every summer with only one exception. The Festival originated in the earliest outdoor performances at the Oak Park Mall in 1975. Founded by Marion Karczmar, such annual productions as this performance of *Hamlet* employ professional actors. The season is funded by a combination of ticket sales as well as public and private foundations and agencies.

This 1990 photograph was taken at a rehearsal for an Oak Park and River Forest High School production of *Raisin in the Sun*. Staging a play by an African-American woman playwright and with the active participation of these students, Mecca Thompson and Carnell Burlock, indicates both the breadth of the material presented and the diversity of the student body at the high school.

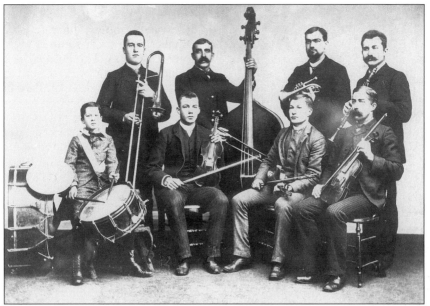

The original Oak Park Orchestra is shown here six years after it was founded in 1880. After disbanding in the later 1880s, another group with the same name played a number of concerts of both classical and popular music. Open air concerts were offered on the grounds of the Farson home and music could also be heard at the Scoville Institute. The current Oak Park- River Forest Symphony Orchestra was founded by Gladys Welge in 1931.

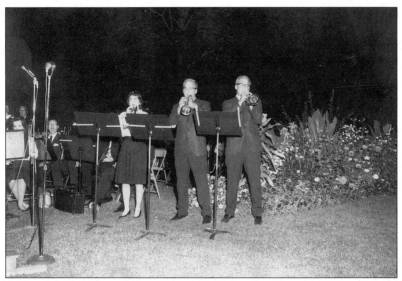

Various kinds of open air music performances have been part of the community since the 1890s. This summer concert was played at Anderson Recreation Center in 1964. Other performances have been at the swimming pools as well as in the courtyard of Village Hall. For many years, the largest crowds have been drawn to a wide variety of free Sunday evening concerts sponsored by the Park District and performed at Scoville Park each summer. (Photo courtesy of Park District of Oak Park.)

Other kinds of music performed in recent years have included the caroling performed by the Sounds of Joy group, founded by Harry Steckman, shown here at the Pinnacle (now Old Kent) Bank in December of 1998. Steckman's School of Music, like the Academy of Movement and Music, combines lessons, performing groups, and raises funds to create opportunities for a diverse student body including those who could not otherwise afford to participate. (Photo courtesy of Steckman Studios.)

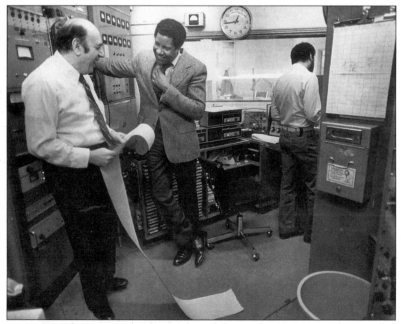

The programming of music and other cultural forms for various audiences has become a part of the broadcast programming facility at the Oak Park Arms. This 1980 photo shows Ron Craven of WBMX (right) and Sidney Schneider of WOPA discussing their daily programs while an unidentified technician checks out the equipment. The tall tower at the Arms beams an array of ethnic programs throughout the area.

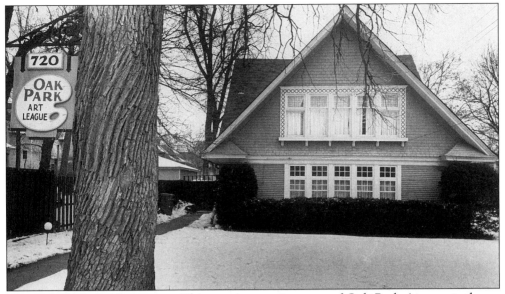

The Oak Park Art League on Chicago Avenue just east of Oak Park Avenue is the oldest continuously operating organization devoted to the visual arts in the Village. It was founded in 1921 by a group that included several recognized professional artists. It acquired the building pictured here in 1937 and has always offered a complement of classes, exhibitions, and speakers on various artistic subjects.

The Oak Park Area Arts Council was founded in 1974 as an umbrella organization that could enhance public awareness of the arts already available in the Oak Park area, coordinate activities and calendars, attract grants for use and regranting, and encourage the development of further interest in the arts. It sponsors art walks, exhibitions, and such projects as this 1988 mural painting at the Oak Park Mall.

Oak Park resident and then professor of art at Rosary College, Geraldine McCullough, had already received many important public commissions when a citizen group approached her about designing a sculpture to be placed at the new Village Hall. Private funds were raised for the material, while the artist donated her time and labor. This photo shows the unveiling of *Pathfinder* at its site on Madison Street.

Not all art for the public was created by well-known professionals. This 1981 photo shows the young people of Girl Scout Troop 265 preparing the wall of the viaduct at Kenilworth and South Boulevard. The mural they were going to paint was part of a plan to beautify the community. Other viaducts were painted in the 1970s, including the one at Austin Boulevard, a joint project of neighbors from Oak Park and Austin.

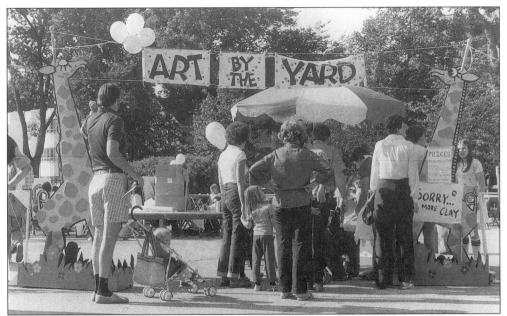

At the many outdoor craft and art fairs, juried exhibitions, and other public art events, inspiring children to be creative has usually been part of the agenda. This Village Art Fair of 1979 includes various forms of art for the children to try. A disappointed family reads the sign that informs them that the Fair has run out of clay, one of the casualties resulting from such great interest in the Art Fair.

"Art in the Park" was an annual event in Mills Park. In the 1980s and early 90s it attracted both the professional and amateur artists who made the rounds of all the summer art fairs as well as locals who were trying their hand at exhibiting for the first time. This 1990 photo shows some entrepreneurial 3-5 year olds who are counting the profits they made on selling the work they created that day.

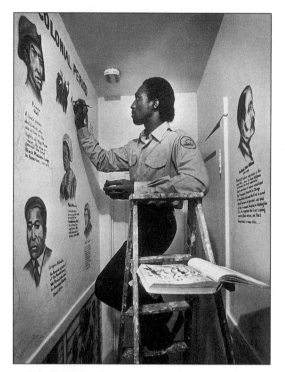

Some public art is displayed where the artist finds an appropriate spot. This undated photo shows Amir Sharif portraying important African-American men and women in a mural he created in honor of Black History Month. His mural of portraits and text is in the hallway of an apartment house on Washington Boulevard. The open book on the ladder contains images that inspired his vision.

In the 1990s, Harrison Street became the home of several artist's studios, workshops, and crafts people. The trend continues today. Renee Carswell, A.M. Kawamoto, Tia Jones, Jonathan Franklin, Mark Finger, and Kathryn McAllister are six of the artists who have been active in the area. They are shown posed in front of the banners they created for the Harrison Street Business Association in 1995.

Seven
RELIGIOUS LIFE

The manifestations of religious life are basic to any community, and Oak Park has a long and complex history of organizing, developing, merging, and closing houses of worship. It is also a very rich religious environment, with multiple churches of the same denomination; with a history of dissent and creation of non-conformist congregations; with tolerance for diverse and minority religions. Religion and the Temperance Movement were intertwined in the early years, and up to the 1970s in the hearts and minds of some, and the "dryness" of the town contributed to an attraction for people of a certain religious persuasion. There is also a history of the absorption of one group by another, many mergers, and heated discussions of whether to accept certain congregations within the framework of "Christian" or not. As the community became more diverse, and successive Village Boards of Trustees adopted and expanded a statement on diversity, additional congregations formed along racial, language, and sexual preference lines. Amid controversy and withdrawal of some congregations, the Council of Churches metamorphosed into the Community of Congregations, Catholic-Jewish dialogue groups started to meet, and discussion of inclusion and exclusion was brought out into the open. In the year 2000, denominational, interdenominational Christian, and ecumenical organizations and programs provide opportunities both for those who wish to worship and participate in social activities within their own religion and those who enjoy worship, discussion, and good works in the company of people of various faith traditions.

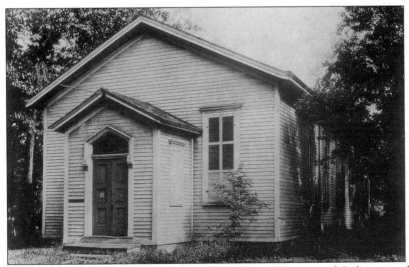

Though this little building at the northwest corner of Forest and Lake served as the first school in Oak Park in the mid 1850s, its role as temporary home to many congregations until they could build their own structure gave it the affectionate nickname of "Mother of Churches." It became Temperance Hall when Henry W. Austin made it the headquarters of the Temperance Movement in Oak Park. It was also used for other social functions until razed in 1901.

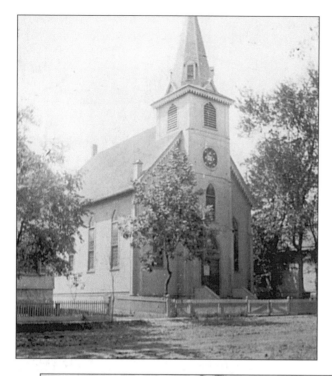

The German Evangelical Lutheran Church, St. Paul's (later the Evangelical United Brethren), shown here in 1902, was one of the earliest churches in the area, founded as a congregation in 1867. The building was converted to use as a parsonage in 1896 when the new church was built. The buildings were sold to Bible Truth Chapel in 1920 and later destroyed to provide parking for a nearby congregation.

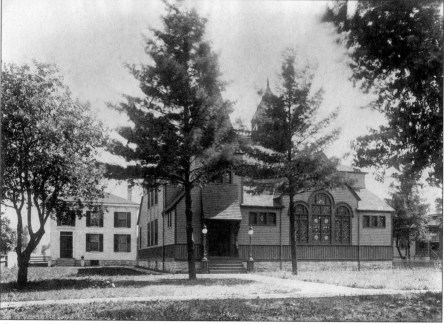

The first small group of Presbyterians organized a church in 1883 and met in temporary quarters until they could build their frame home on Lake Street west of Kenilworth in 1886. This turn of the century photo shows the expanded building before it was replaced by a much larger structure of stone in 1901. The congregation merged with the nearby First Congregational Church to form First United Church in 1975, leaving other Presbyterian congregations intact.

Mt. Carmel Colored Baptist Church was founded just east of Harlem on Williams (now Westgate) in 1905. It served the small, local Oak Park African-American Community in place of the storefront space they had been renting on Lake Street. The funds for the church had been raised by the congregation and with the support of local millionaire John Farson. The congregation consisted of no more than 20 families when disbanded in 1931.

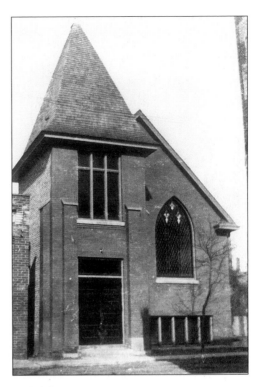

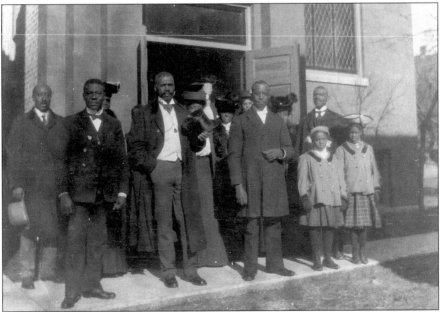

Members of Mt. Carmel pose outside the church on a Sunday morning soon after its founding. The Church served both the families of independent entrepreneurs and the larger number of people engaged in hotel, domestic, and transportation work. As the commercial area of downtown grew after the opening of Marshall Fields in 1929, housing was replaced by businesses and the small black community was effectively dispersed.

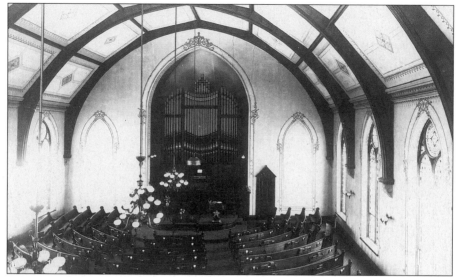

The origins of the Congregational Church were in the Union Church that was founded in 1863 as an Evangelical but non-sectarian group. It was reorganized as First Congregational in 1871. The interior, pictured here in 1885, was taken after it had already been enlarged twice. Just west of the Scoville Institute (later the O.P. Library), the gas fixtures illuminated what was the largest church interior in the community.

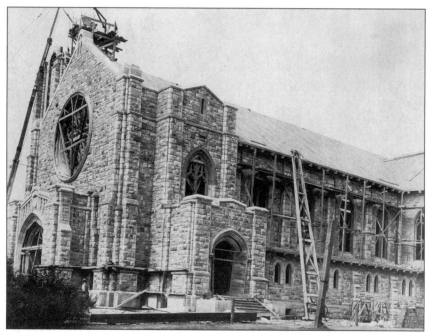

A fire destroyed First Congregational Church in 1916. This photo illustrates its reconstruction a year later. The pastor, William Barton, was renowned both as a minister and as a writer. There were six local Congregational churches by World War I, but many merged, moved, or closed their doors by the end of the Depression. Today, First United Church, the union of the old Congregational and Presbyterian congregations, occupies the building.

Oak Park's liberal Unitarians and Universalists built their church on Wisconsin in 1872 when the old Unity group became Congregationalist. When their building burned in 1905, Frank Lloyd Wright was asked to build a new structure in the heart of the Village opposite First Congregational, creating his world renowned masterpiece. It was dedicated in 1909 and has since absorbed several other congregations.

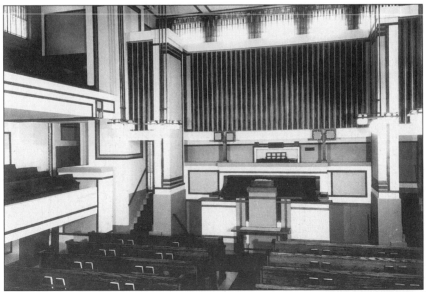

The Noble Room is what Wright called the sanctuary of Unity Temple, which also has a smaller cube shaped structure that serves as the social hall. A National Historic Landmark and a daring reinterpretation of the old New England Congregational church type, the congregation recognized its importance by supporting a separate restoration organization and granting the first protective interior and exterior easement of a church in the United States.

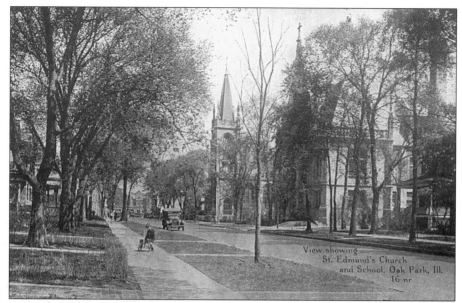

There was hostility toward allowing a Roman Catholic church to be built in Oak Park when the St. Edmunds parish was established in the early years of the twentieth century. But John Farson, a leading citizen, lent his name and support. The building seen on this early postcard was completed on the corner of Oak Park Avenue and Pleasant Street in 1910 as the first of four Catholic churches erected in the community.

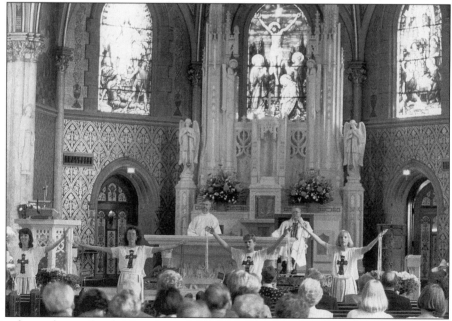

This photo shows the celebration of the 75th Anniversary Mass at St. Edmunds, and suggests the richness of its decorative scheme. Just as changes in the liturgy affected Roman Catholic churches in the 1960s, new plans in the late 1990s pitted those who wished to restore the building with emphasis on the design and appearance against those who emphasized the liturgical innovations and organization of the day.

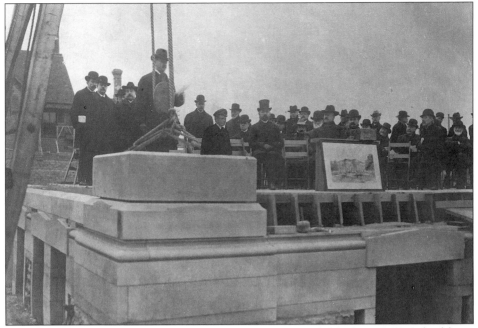

This 1903 photo depicts the cornerstone ceremonies of the first YMCA building in Oak Park. The lot on North Oak Park Avenue was donated by Charles Scoville and faced the original family estate. A new YMCA was built on Marion and Randolph in 1954, offering more opportunities for both housing and recreation. It has been modernized and is open to a more diverse membership reflecting modern Oak Park.

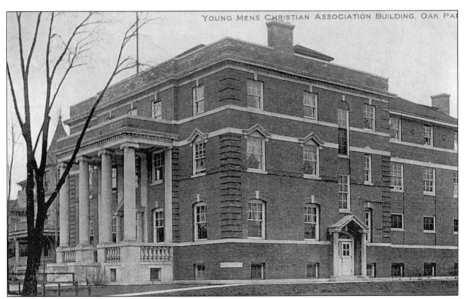

This penny postcard shows the newly completed YMCA building, a structure with a world class swimming pool and up-to-date amenities. When it outlived its original function, the building was purchased by Emmaus Bible School and served as a residential campus. When Emmaus left, the building was turned into condominiums, following in the adaptive reuse path of the Oak Park Club a block to the north.

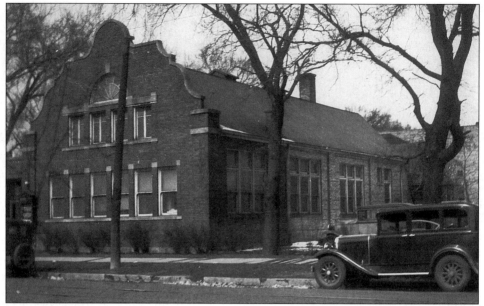

The Madison Street Nondenominational Church, shown here around 1928, was built at the corner of Madison and Wisconsin in 1921 to replace the storefront church started at that location in 1915. The church had a missionary Fundamentalist orientation and later became Calvary Memorial Church. The building was destroyed by fire in 1977 and the site became an automobile dealership parking lot. New residential units were built on the site in 1999.

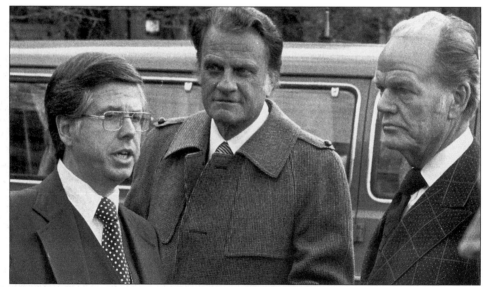

After the creation of First United Church, the old First Presbyterian Church building was acquired by Calvary Memorial Church. Here we see the well known evangelist Billy Graham (center), flanked by Reverend Donald Geris and local radio commentator Paul Harvey, at the re-dedication of the congregation in their new home in November 1979. The congregation continued to grow and was considering expansion plans in 2000.

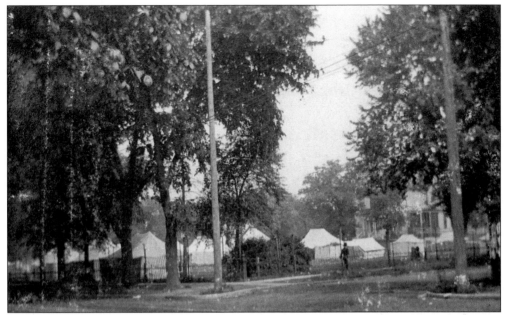

Reverend William E. Barton, the author and minister of First Congregational Church for over a quarter century, hosted many religious activities, including revivals. This photo, c. 1900, shows the "tent city," erected in today's Scoville Park in which those who traveled from afar were able to stay during the several days of sermons, meetings, and open declarations of faith.

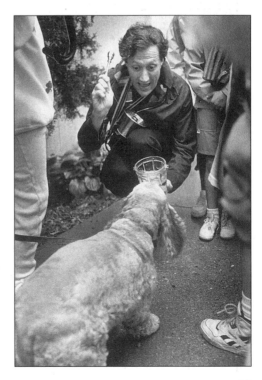

The desire to blend serious religious belief and the needs of children led to the somewhat controversial ceremonies of Pet Blessings. This 1990 photo shows Father John Boivin of St. Giles Roman Catholic Church, blessing a dog, Barley.

This large First Baptist Church grew out of similar humble beginnings as First Congregational, when a small group of people organized in 1873. After meeting in Temperance Hall when the building was available and in the homes of its congregates when it was not, the Church moved into its own home in 1883. After years of growth and prosperity, the current building pictured here opened in 1923 after a fire destroyed its first home.

The Baha'i adherents of Oak Park have been meeting as a Spiritual Assembly since 1940, though there were adherents here since 1898. As the faith has no clergy, the Assembly administers the affairs of the community. The Oak Park Baha'i Community has been a pioneering force; it was one of the first to incorporate in the USA and the first Baha'i civil marriage in the country was for an Oak Park couple. (Photo courtesy of Baha'i Community of Oak Park.)

Although Congregation B'nai Abraham Zion is one of the oldest continuous Jewish congregations in the Chicago area, the current building, Oak Park Temple, first opened its doors in 1958. Earlier attempts to secure a site for a synagogue were rebuffed. Pictured here is the dedication service in which the newness of the building is evident in the bare walls and the pew's empty book holders. (Photo courtesy of B'Nai Abraham Zion.)

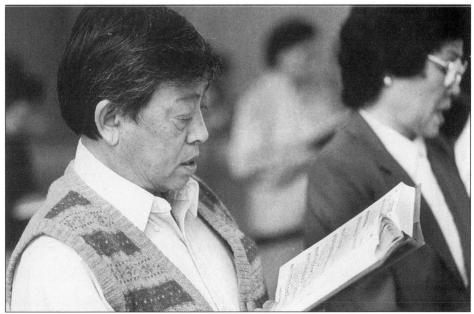

The Chinese Bible Church on South Ridgeland at Jackson Boulevard was founded in 1979, occupying the space previously used by the Oak Park Christian Church. Services, as pictured here in 1990, are conducted in both English and Chinese. The congregation draws its members from a wide geographical area of the suburbs.

Reverend M. Randolph Thompson organized a group of Evangelical Covenant Church adherents into a new church in 1995. The Fellowship Christian Church on Madison Street, west of Wisconsin, occupies a building that formerly served as a funeral home. The effort to convert the structure into church use raised issues of zoning, religious freedoms, and racial intolerance. Today, the racially diverse congregation is an established part of the community. (Photo by author.)

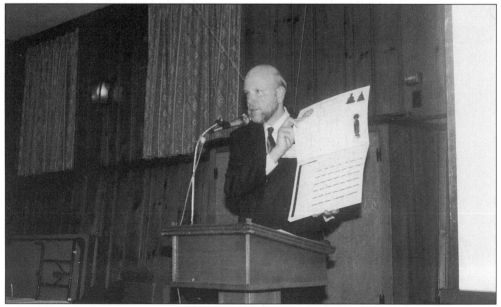

The clergy and lay leadership of the Council of Churches became the Community of Congregations, opening its doors to Baha'i, Jewish, and Unitarian congregations in the early 1990s. The expanded organization sponsors a variety of activities and programs supporting social justice. Pictured at the 1992 annual meeting is the keynote speaker and Oak Park resident, Reverend Stanley Davis, the Executive Director of the National Conference. (Photo courtesy of Community of Congregations.)

Eight

EDUCATION

A basic piece of Oak Park lore tells of the story of Joseph an d Betty Kettlestrings. As the first settlers of Oak Ridge, they left their farm near Lake and Harlem, on which they had lived since 1835, and moved to Chicago in 1843 to educate their children. They returned in 1855, donating a parcel that housed the first local school from 1857–1859. Demands for educational opportunities grew with the increase in population, especially after the Chicago Fire forced many families to flee the city for the close-in suburb of Oak Park. Cicero Township School District No. 1 started a 12-grade district in 1857; Central School opened in 1859 and a separate high school was opened in 1891 at Lake and East. There were a dozen public schools in use by the end of World War I. Fenwick High School for Boys opened in 1929, joining the growing number of private and parochial elementary schools in the community. A Catholic military school opened in 1917 and a private junior college in 1933. There were also a number of other private and religious schools, but they closed their doors during or soon after the Great Depression. The private junior college failed to compete with the growth of public higher education in the Chicago area. A number of alternative elementary schools opened in the sixties and early seventies, but they, too, failed to survive. Home schooling and Montessori schools provide additional options and enrich the educational mix of public and parochial schools in the year 2000.

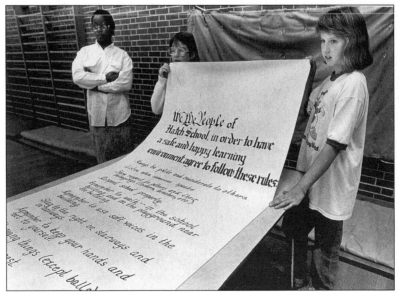

Fifth graders at Hatch School are shown with their newly ratified "Hatch Constitution" near the start of the 1987 school year. The list is a combination of rules and requests for collegiality that grew out of discussions with the students as to what behaviors might be necessary to create the best learning environment. The project symbolizes student based education that has become one hallmark of Oak Park's public educational system.

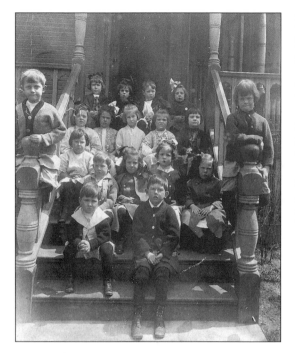

Kindergartens have been around since the early days of Oak Park's history, with Mrs. Frank Lloyd Wright's wife, Catherine, running one of them in the playroom of their home. This photo shot around 1911 pictures the young scholars of a private home-based kindergarten on South Kenilworth Avenue. Most were co-educational and were influenced by continental—usually German—progressive education models that combined pedagogy and play.

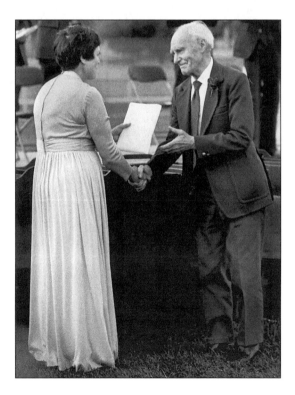

Education was never just for the young in Oak Park. Most adult learning was confined to the credit and enrichment courses offered by the local community college and those sponsored by the Recreation Department or the Park District of Oak Park. Some took their learning very seriously, evident in this image of William Barlow, a World War I veteran, receiving an honorary degree after auditing all four years of classes at OPRF High School.

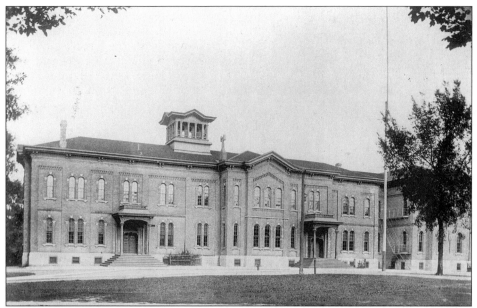

Central School opened as the original Oak Ridge School in 1859 at the Southeast corner of Lake and Forest. The central section of the building, as seen in this 1900 photo, burned in 1923. The new and expanded building was renamed after the poet James R. Lowell. Razed in 1972 it is the only Oak Park public school not to remain on its original site.

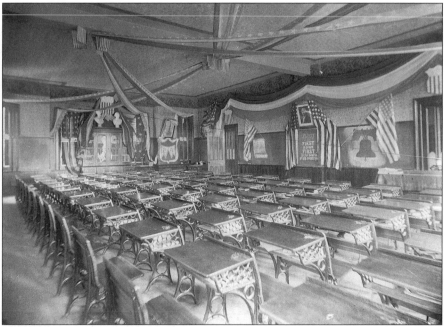

This 1889 photo depicts the interior of the high school room within the old Central School. There were 122 students when the first high school building was opened in 1891. Classes were as big as necessary within the space at Central, and over one hundred desks were placed in the patriotically large room pictured.

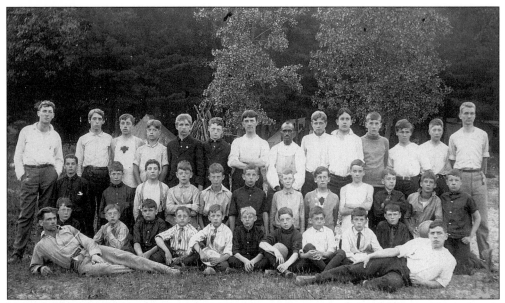

Neighborhood schools were assumed in the early years of the Village. The schools proliferated in response to the subdivision of properties and population growth. Holmes School began with two brick cottages in 1889 and served West Central Oak Park through the eighth grade. David Wright (behind the instructor at lower left) was one of the neighborhood kids who walked across the street from the Wright Home, c. 1906. Now, in 2000, middle schools will be replacing junior high schools.

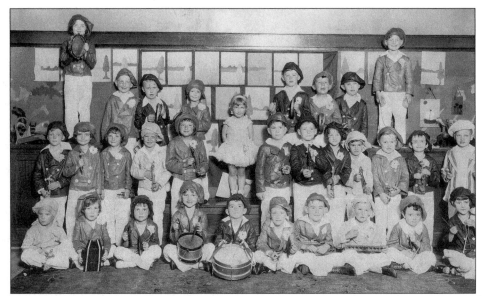

Each school had its own local administration, character, and specialties. This 1928 photo shows the children who were members of the "kindergarten band" at Lincoln School. This site was developed to accommodate the growing population of South Oak Park in 1906, having two additions before World War I. A larger addition was completed in 1929. Private kindergartens could not compete with public school facilities and largely disappeared by 1920.

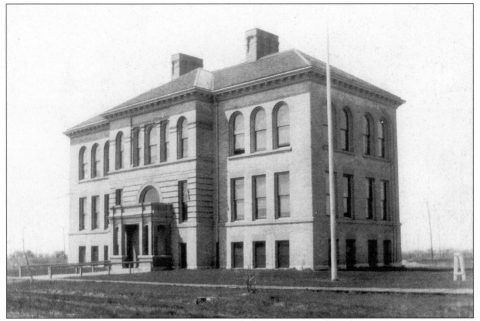

Shown here in 1907, the image of the Longfellow School illustrates the sparsely settled nature of the area south of Madison Street. The Gunderson subdivision and other home building made the old "Highland Avenue School" obsolete. The East Village between Madison and Harrison soon rivaled other parts of town in the demand for elementary education. This pattern was later repeated across the southern and northern sections of the community.

Founded in 1917, Bishop Quarter Junior Military Academy was named for the Catholic Bishop of Chicago, Bishop Quarter. It was a boarding school with approximately one fourth of the population commuting as local day students. The curriculum was traditional and the discipline rigorous; opportunities for interaction with the young men and women at the public high school right across the street were minimal. The school closed in 1968.

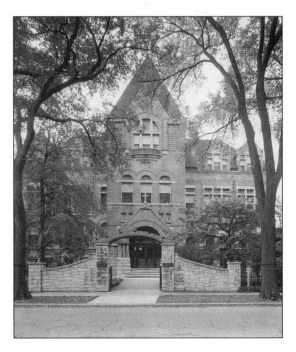

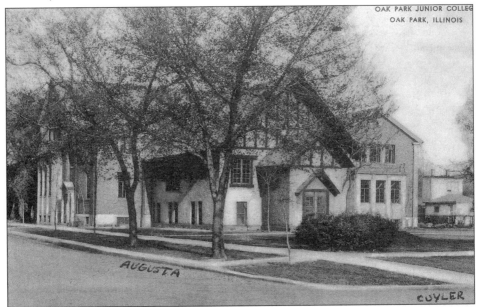

Oak Park Junior College first rented the North Congregational Church in the Fall of 1933 after plans to have the High School district meet the need for such a facility became a hot political issue. A board of local citizens organized the college to offer inexpensive liberal arts higher education in a curriculum that would meet the transfer requirements of the University of Illinois and other colleges and universities.

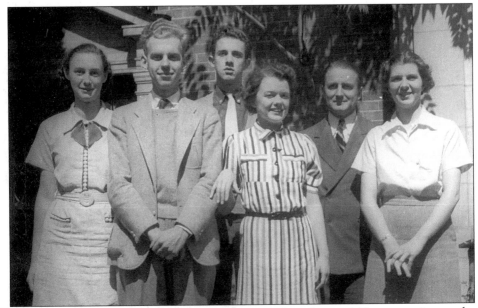

The student body at Oak Park Junior College numbered over 140 commuting students in the 1936-37 academic year when this photo of the student council was taken. There were twelve faculty members, offering about fifty courses, and the tuition was $65 in the middle of the Depression. There were minimal non-classroom spaces. Support for the operation was difficult to obtain and the College closed its doors in 1938.

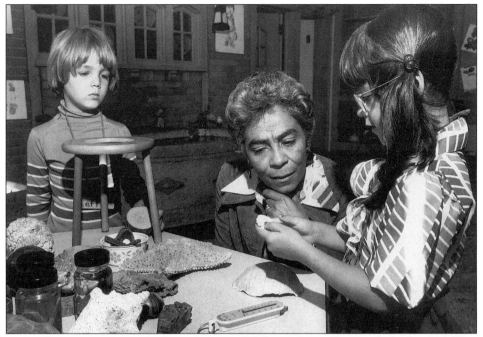

District 97 was reorganized after substantial debate about the needs for both different peer groupings as well as the importance of racially balanced schools. Beginning in the Fall of 1977, the ten neighborhood elementary schools were reorganized into eight K-6 and two Junior High Schools. Dr. Elsie Harley, of Wm. Beye School, became the first African-American principal and helped develop programs for a diverse student body.

Through the 1970s and 1980s, District 97 experimented with various types of instructional models: Pods, special gifted programs, and various approaches to special education needs. Formal structure was replaced by a new openness. It is obvious in this 1990 photo that students like Anna Peterson of Longfellow School were able to concentrate as hard as students who had sat with folded hands in the early years of the century.

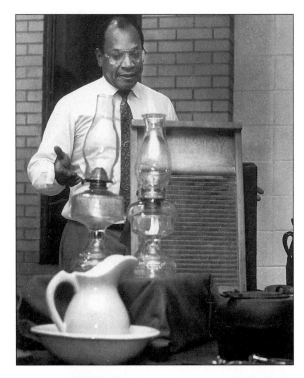

The curriculum continued to evolve following the 1977 reorganization. More specialists and multi-cultural material became available to Elementary and Junior High Schools alike. District-wide-training was supplemented by bringing in outside experts. This 1990 photo shows William Branch, Director of the Heritage Educational Institute, presenting a lesson on some of the material contained in the exhibit, "Images of the Black Experience."

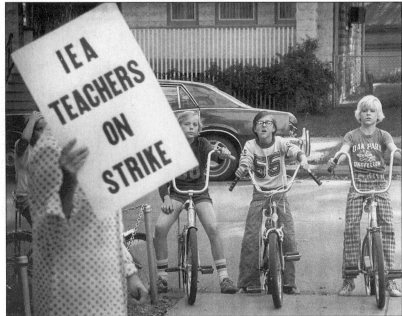

Teachers in Oak Park's Elementary District 97 had long felt that they were inadequately compensated and were frustrated by the District's position that it was illegal for them to undertake any job action like a strike or slowdown. However, the Illinois Educational Association finally struck at the start of the 1976-1977 academic year. These Longfellow students examine their picketing teachers with faces that suggest an array of emotions.

This 1890 photograph is of young men graduating from Oak Park High School, but it might as well represent just a group of friends captured in a formal picture taken by one of the several Oak Park photographers of the day. The curriculum was divided between the liberal arts and sciences, and before a manual trades division started in the early twentieth century, many left to go to work before graduating.

Fenwick High School opened as a boys' college preparatory school in 1929. It maintained its mission of providing a traditional curriculum of "basics" designed to ensure academic success in college. It also fielded successful athletic teams through much of the almost seventy years of its existence. After substantial debate, the school began accepting girls in 1992, without any other change in orientation or quality.

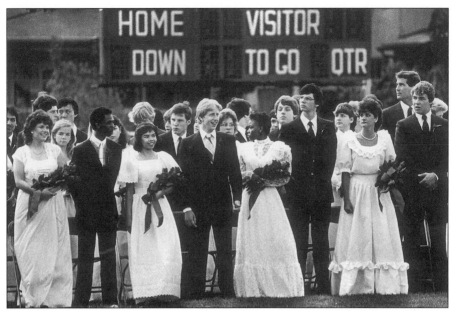

Traditions have always been strong at Oak Park River Forest High School: The women have always worn white dresses and carried flowers at graduation while the men have worn dark suits. By the early 1980s, the student body was more diverse than ever before and some traditions were being challenged. Real change was slow in coming and the 2000 graduating class was the first where women were allowed to wear pants at the graduation ceremony.

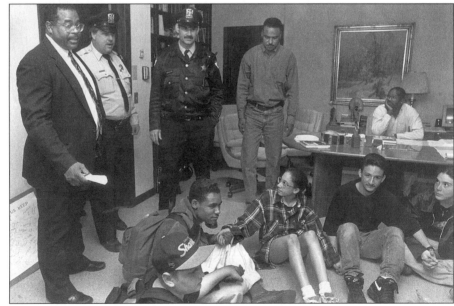

Just as formal dress regulations were being challenged, OPRF High School students questioned both the values of the school and society at large, sometimes by taking part in formal and organized forms of protest and sometimes by staging their own demonstrations. This 1994 photo shows Associate Superintendent Al Sye warning the students to end their protest or face arrest by the local police.

Nine

HEALTH AND WELFARE

During the earliest years of settlement of both Oak Ridge and Ridgeland, there were few municipal services and even fewer to meet the medical needs of the rapidly growing community. The influx of residents after the Chicago Fire of 1871 caused the population to jump from an estimated 500 in that year to over 10,000 by the time of the first attempt to create a hospital for Oak Park and the 60,000 people in the old Cicero Township in 1904. By the outbreak of World War I, there were two fully operational hospitals: Oak Park Hospital and West Suburban Hospital, both growing over the years. Other social services developed by private initiative. An orphanage, day care centers, nursing homes, clinics, and other facilities were started by individuals or groups of citizens who incorporated and convinced the philanthropic community leaders to serve on the Boards that administered and supported the new agencies. Fraternal organizations often adopted particular local charities as part of their commitment to goods works. Oak Park is still home to both traditional and unique organizations that are dedicated to helping those in need. The original hospitals are still there, but public services are now augmented by such organizations as Sarah's Inn for abused women, Tri-Village Pads for the homeless, Community Response for those suffering with AIDS, group homes for those adults in need of assisted living, and many other groups and organizations. Private and public agencies receive support from local government and the Community Chest to provide an unsurpassed range of services and support.

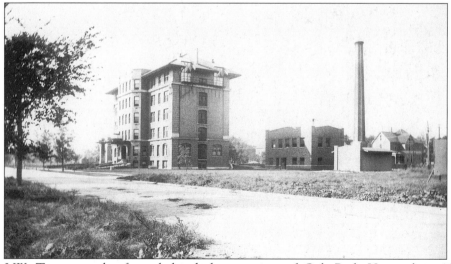

Dr. J.W. Tope was the force behind the creation of Oak Park Hospital in 1904, however, because of opposition to having a hospital in a residential neighborhood, it was 1907 before it opened under the auspices of the Sisters of Misericorde. The public soon recognized its value, yet each proposal for enlargement produced the same opposition as the original plan. The 1999 Physicians Building Proposal was as unwanted as the original building.

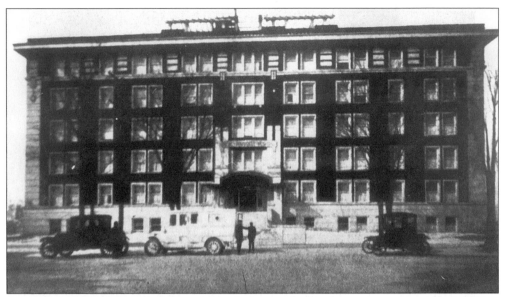

As with Oak Park Hospital, the original plan and all subsequent expansions of West Suburban Hospital were opposed by neighbors who feared noise, traffic, and a loss of property values. The first construction permit was only issued as the result of court action. The original building has had a number of additions and soon became known as a major maternity center. By the 1930s, the hospital had become Oak Park's largest employer.

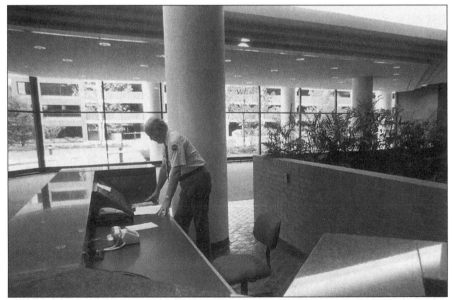

The purchase of homes in the area through the 1970s provided West Suburban Hospital with the space necessary to open a state of the art addition containing physicians' offices and a modern HMO with full access to all the facilities of the hospital. A new parking garage with an underground passage linked all parts of the facility. The pictured central interior court serves as the center for reception, security, and auxiliary services.

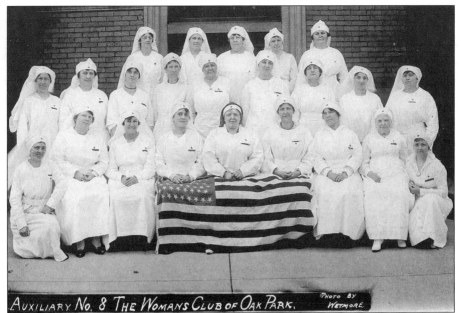

The Red Cross Woman's auxiliaries were an important part of the war effort for both World War I and II. From preparing bandages and medical supply packaging to the less formal activities of knitting warm socks and mittens, the women pictured here near the end of WW I performed many functions in support of the military. The uniforms were meant to create an identification with highly respected professional nurses.

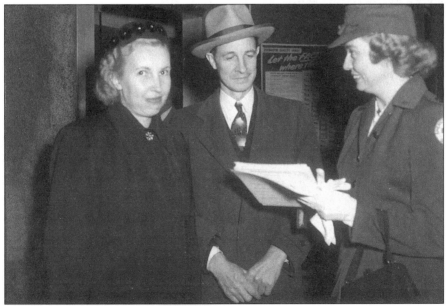

The local civic and fraternal organizations helped support the annual blood drives and made it a point of pride to get as close as possible to 100 % of their members to donate blood to the local blood bank; many groups still host an annual drive, 50 years after this 1951 solicitous Red Cross professional. (Photo courtesy of OPRF Chamber of Commerce.)

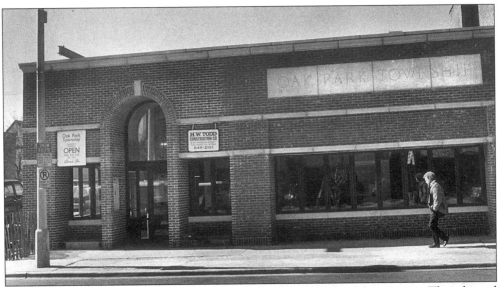

Oak Park Township provides senior, youth, and mental health services. The elected Township Assessor is the local official in charge of property assessment and has an office there. The Township Board sets the policies for the social service programs and cooperates with private agencies as well. All of these functions can be addressed by a visit to the Township Hall at 105 S. Oak Park Avenue, renovated and updated in 1987.

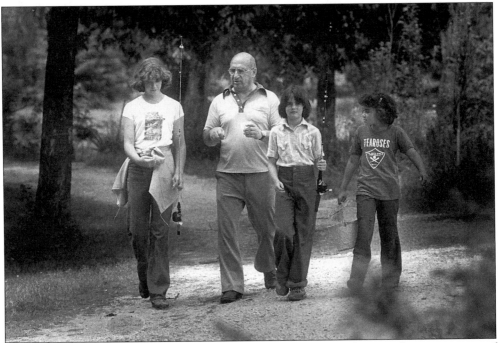

Social Service programs have changed through the years along with perceptions of need and the interests of the staff and Board of the Township government. This 1979 photo pictures Joe Savino, then Director of Township Youth Services, with some of the youth he would personally accompany on his Take a Child Fishing program.

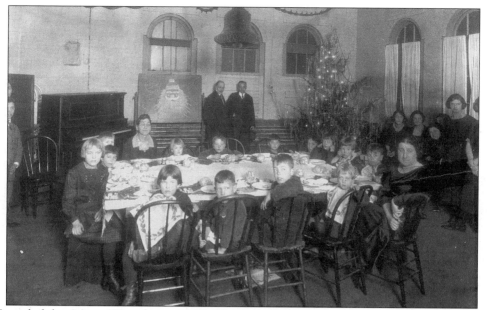

Founded by Mary Wessels in 1897, Hephzibah ("comforting mother") Home was incorporated as an orphanage in 1902. It grew and flourished at several successive locations near its present home on North Boulevard. It existed on voluntary donations and varying amounts of support from the Economy Shop and the Community Chest. This 1920 photo shows the children and staff at the communal dinner table at Christmas.

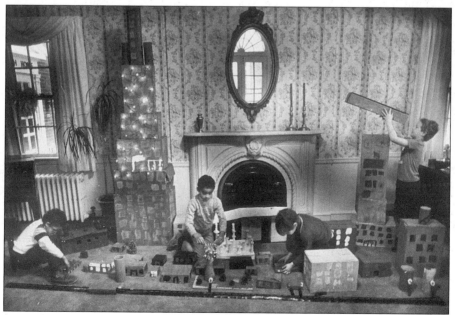

By the early 1970s, there was little need for orphan care, yet great demand for after school day care. Mothers at Hawthorne (now Julian) School approached Hephzibah and worked out what proved to be only the start of an after school program that grew to encompass the entire Village, and which now works with DCFS as well.

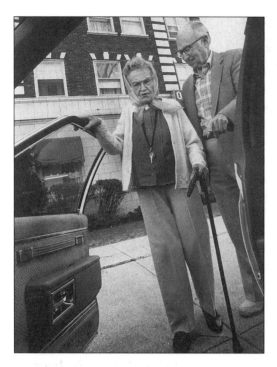

Unlike many communities where volunteerism evolved from outreach from person to person, through organized help, and then to total reliance on a paid staff of professionals for support and care, Oak Park volunteerism continues to evolve and thrive. Pictured is Merton Paddleford, 80 years old in 1991, helping Irma Lane into a car for a trip from the Oak Park Arms to her doctor: part of his participation in the volunteer organization Assist.

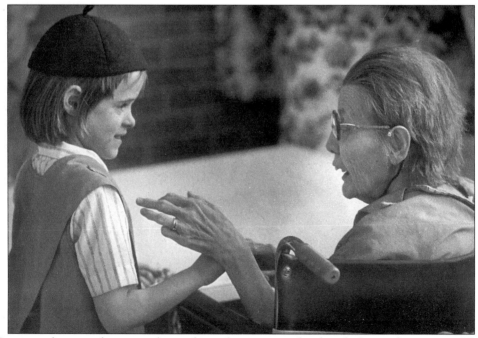

Senior volunteers have not been the only ones involved in helping their peers. This touching 1979 image shows one of the young girls in a Brownie Troop who visited the Oak Park Convalescent Center as part of her regular activities. Strong bonds have often been created through such visits, with the youngsters "adopting" a senior citizen with whom they maintained contact over time.

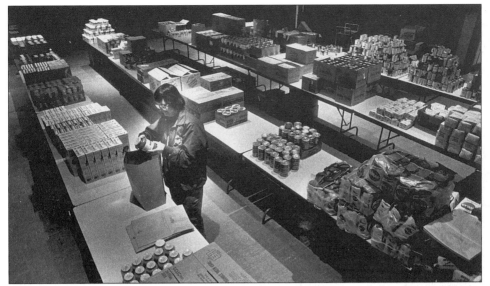

The Food pantry of Oak Park has long been a project of the Community of Congregations as well as various religious institutions and individuals. This 1985 photo shows the longtime coordinator of the Food Pantry, Pat Koko, packing food for an Easter Basket at the then home of the organization at Faith United Church. Food is distributed every week, but special attention is paid to providing for the needy at Thanksgiving and on holidays.

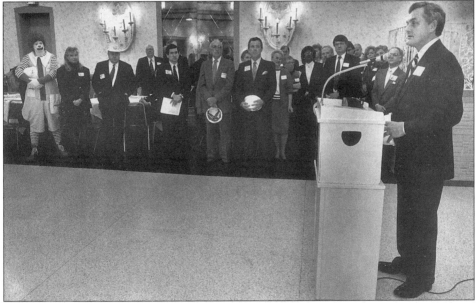

The growing need for provision and consolidation of mental health services led to the decision to buy and demolish the vacant Lamar Theater and build a new facility. With support for the building from family of the genius behind the success of McDonalds, Ray Kroc, and the then President of the Illinois Senate, Oak Parker Phil Rock (at the podium), ceremonies in 1990 were attended by elected and volunteer community leaders.

Not all health and welfare activities are in the hands of volunteers or local organizations. Such national bodies as the Easter Seal Society maintain offices in Oak Park. Here, we see physical therapist Maggie Summerfeld working with an appreciative two-year-old, Tiffany Patterson, in 1988, at the Madison Street local headquarters of the organization.

Children learn about health issues and proper diet in their schools as well as their homes. The schools offer a range of health services, provided by the Village government, that supplies trained nurses to the elementary schools. This 1990 image shows two Hatch Elementary School fifth grade students as actors in a performance of "Pinocchio, Don't Smoke That Cigarette."

Ten

SPORTS AND RECREATION

Even before all the land surrounding the Village was filled in with residential and commercial development, there were those prescient enough to recognize the need of outdoor space for relaxation and recreation. Baseball, golf, and cricket were played on large pieces of undivided land, and some recreational activities were sponsored by the larger landholders. Though state enabling legislation had created the possibility of establishing a local Park District with taxing powers as early as 1895, it was not until 1912 that the local District was approved by voters. The five Commissioners began to acquire property for parks throughout the community. Scoville Park, Ridgeland Common, South Park (now Rehm), and Taylor Park were established in the first two years of activity. Today's set of parks, parkways, and field-houses was in place by 1935. The Village's Recreation Department was later folded into the Park District.

Team sports predominated in public spaces, with the growing number of youth oriented activities equally divided between sports and handicraft activities in the field-houses. The Great Depression further channeled activities into public spaces, and supervised organized activities became the norm. In the 1960s, pre-school, youth, adult, and senior programs were flourishing in the recreation centers, and the field houses had heavy traffic all year around. The Park District staff now runs sports, crafts, dancing, music, and many other activities through its programs, bringing entertainment and activities onto the streets as well.

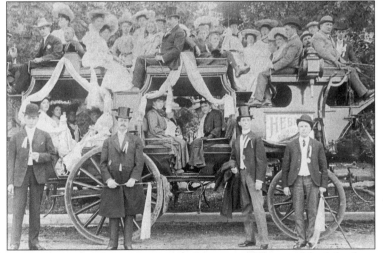

Horse shows and mounted parades were a big part of the world of the horsemen in the late nineteenth and early twentieth centuries. Affluent men like Pleasant Home owner John Farson kept and showed horses. This elaborate carriage is the backdrop for one of the annual events that brought out these people in full regalia. They also raised money for charities through their activities. There were also racetracks in surrounding areas.

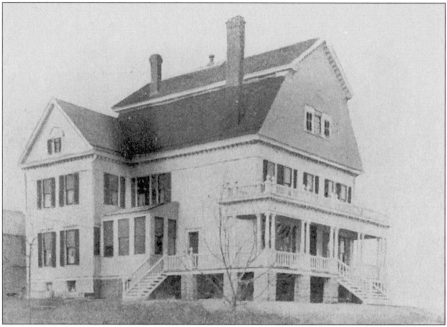

This building was the clubhouse for Westward Ho Golf Club, then at the corner of Ridgeland and North Avenue. Around the time of this 1898 photograph, golf was very popular in the Village, but the increase in real estate values put the several clubs out of business by World War I. When the Oak Park Country Club was founded in 1914, it was necessary to build outside the community to afford sufficient land for golf.

Golf became more of a coed game after WW II, especially as there were more retired seniors. With the opening of public courses in Columbus Park in the next door Austin neighborhood and various other public courses, Golf became less a game for only the wealthy. This photograph shows a group of seniors practicing their putting at Taylor Park in a program sponsored by the Park District's Senior programming division. (Photo courtesy of Park District of Oak Park.)

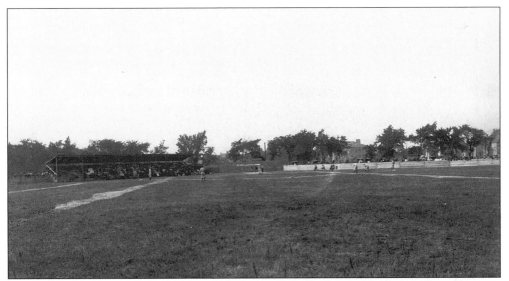

Baseball was America's pastime as much in Oak Park as elsewhere. There were a number of ball fields in use at the end of the nineteenth century. This 1896 photo shows a game in progress at the Baseball Grounds on Madison Street between Home and Kenilworth. As residential dwellings were built in the area, new ball fields were built by the Park District and remain in great demand.

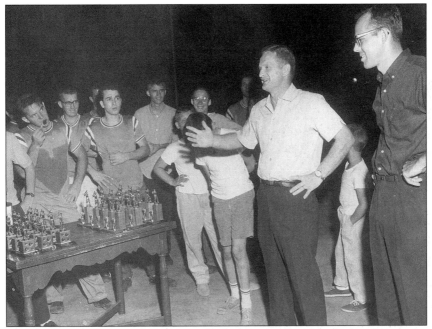

While baseball remains popular among both boys and girls of school age, there has been increased adult interest in Oak Park in both soccer and softball. Pictured is the award ceremony of the young men's champion softball teams of 1962. By the early 1990s, every available field was in use until late in the night in Summer months, with games starting as late as 10:00 and women pressing for a greater share of the available time slots. (Photo courtesy of Park District of Oak Park.)

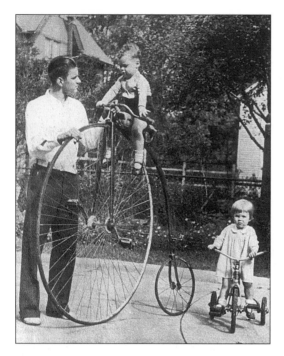

Bicycling in Oak Park shared the national craze in the 1890s. Before the streets and walks were paved in the early days of the twentieth century, the hardy enthusiasts and commuters rode on dirt roads. After the automobile became popular, cycling became a form of recreation and transportation for children too young to drive a car. This undated photograph shows one child on his tricycle and another trying out their father's "bonecrusher."

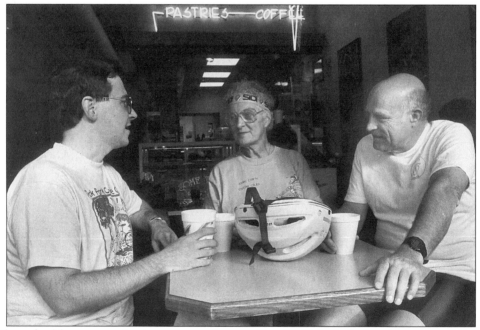

There had been organizations devoted to cycling in Oak Park for close to a century when this photo was taken in 1994. Members of different ages and genders belong to the Oak Park Cycle Club are shown here having some refreshments at a local coffee shop, Something's Brewing, after their ride. Distance riding is important for many. Participation in trips of one hundred miles or more earn money to support favorite charities.

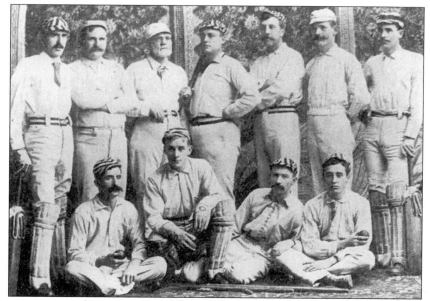

Cricket was a popular game for adult men in later nineteenth century Oak Park, as seen in this 1892 photograph. Perhaps the English roots of many early settlers contributed to that popularity. Most games were played at the Old Cricket Grounds, on the site of what is now Ridgeland Commons, but by the time the cricket grounds were acquired by the fledgling Park District in 1913, cricket had been supplanted by baseball as the game of choice.

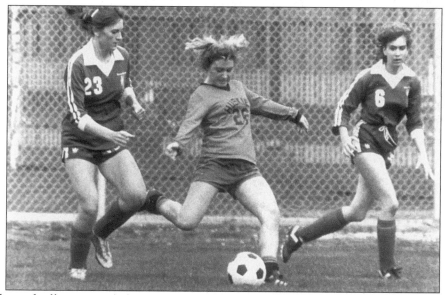

Girls gradually received the same opportunities to participate in sports, both in the schools and in the recreation programs under the auspices of the Park District. This photo taken in the 1980s shows the young women of OPRF High School involved in the increasingly popular sport of soccer. In 1998-99, steps were taken to acquire more land across the street from the High School to accommodate the growing need for athletic fields.

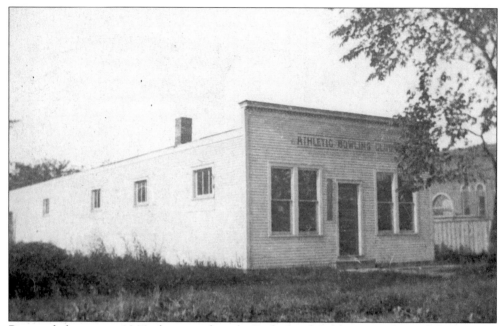

Pictured above in a 1903 photograph is the Ridgeland Athletic Bowling Club, on Lake Street near the Cricket Grounds. The small wooden building contained lanes providing part time jobs for "pinboys" who set the pins up by hand. In later years there were other alleys too, though only one remains within Village borders at the start of the twenty-first century.

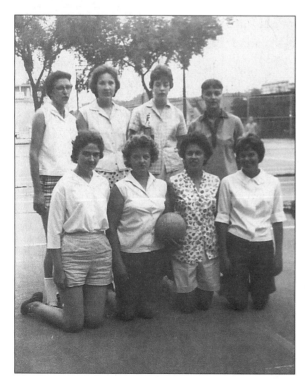

Volleyball became popular after WW II. The sport could be played both indoors and out, an important factor in a northern climate. The Village Recreation Department sponsored men's, women's, and coed teams at the Park District's facilities. Posing on the tennis courts at Stevenson Recreation Center is the 1962 Women's Volleyball Champion team. Like other recreation programs, Volleyball fosters cooperation and teamwork. (Photo courtesy of Park District of Oak Park.)

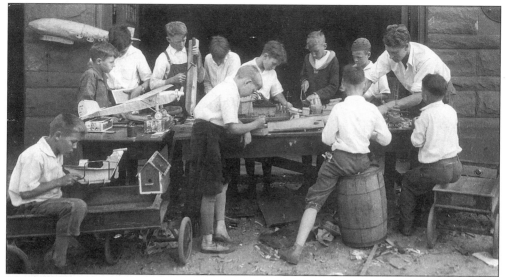

This undated photograph shows the boys who were members of a local handicraft club, busy at work making both model airplanes and boats, probably in the first quarter of the twentieth century. The neighborhood recreation field-houses became the center for such activities in the 1920s. Qualified instructors provided guidance under the auspices of government programs during the Great Depression. (Photo courtesy of Park District of Oak Park.)

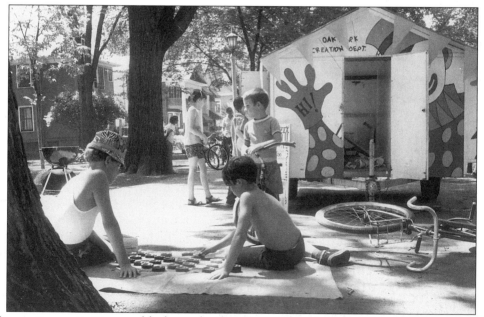

Recreation activities could always be found outdoors, but the Traveling Playground became a staple of summer activities for children in the late 1960s. This 1970 photo shows a street closed off by the Recreation Department as it set up shop and sponsored not only such games as checkers, but bicycle races, arts and crafts, and other amusements. Additional equipment could be reserved and used by local citizens at their weekend block parties. (Photo courtesy of Park District of Oak Park.)

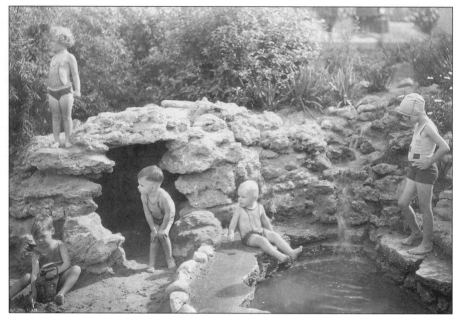

Water sports have always been popular in the summer. This little grotto formed the kiddy pool of choice at Stevenson Playground decades before the creation of major aquatic centers of Oak Park in the 1960s. The little cave was a popular spot, and the proximity of water to the sand made for easy cleanup. (Photo courtesy of Park District of Oak Park.)

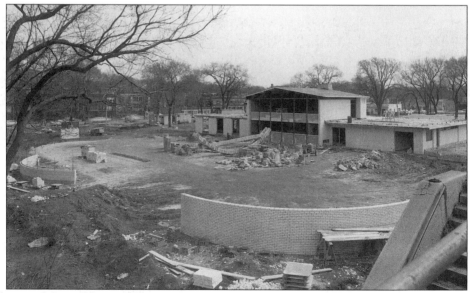

The need for public swimming pools had long been advocated for those not fortunate enough to belong to one of the country clubs or have access to the pools at the Oak Park Club or the Nineteenth Century Woman's Club. This 1962 photo depicts the almost completed Ridgeland building containing the skating rink, concession stand, showers, and the full sized and kiddy pools that are part of the complex under construction. (Photo courtesy of Park District of Oak Park.)

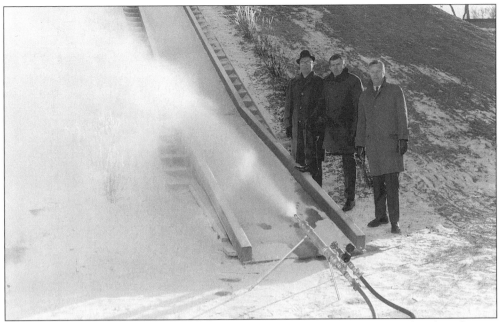

Winter sports include sledding, but there are not many hills in Oak Park other than at Taylor and Scoville Parks. To remedy the situation, local businessmen contributed to the creation of an artificial sled hill on the embankment at Ridgeland Commons. Pictured in the photo are the sponsors and the artificial snow maker that they contributed to the community. (Photo courtesy of Park District of Oak Park.)

Young friends Cristin Glancy and Roszalyne Johnson await their turn to participate in a skating routine in this 1993 photo. Ice hockey was already making major demands on the use of the ice facilities by that date, but such Park District sponsored skating events as an ice show and public skating still hold appeal for both young and old.

Recreation increasingly included a variety of individual sports and challenges in the 1970s as in our own time. Aerobics classes, Tai Chai, and other activities joined gymnastics as popular forms of exercise and self expression. However, such active gymnastics, as pictured with Lynn Allen instructing Jenna Will in how to perform a "handstand straddle press," remained the domain of the younger set.

Weight lifting is now more popular among both men and women as a form of exercise and conditioning, but super achievers like Oak Parker Monroe Saffold fall into another category. This 1990 photo shows the recently selected Mr. America in the Master's Category over 40 showing the form and muscles that won him the title for 1991. Wanting to help others, he assists young men interested in health and self discipline.

The neighborhood pool hall had pretty much disappeared from the community by 1960, and the signs we see in this undated photo are reminders of the aura that the local establishment was trying to overcome. The young man waiting his turn at Oak Park Billiards on South Boulevard plays in a well lighted establishment that welcomes women and sells no alcoholic beverages.

The pistol range at the Park District building on Garfield near East had been in use for a long time and was the only local public setting to practice one's shooting. This 1967 photo shows the professional target setup that was available. However, with the demolition of the old building and the move to the new Park District headquarters on Madison Street in the 1990s, the pistol range was closed.

Team sports remain popular at the turn of the twenty-first century. There is no longer running nor more heated rivalry than between the men's basketball and football teams of Oak Park and River Forest High School and Fenwick High School. Here, Fenwick's Jason Rossi tries to block the shot of OPRF's Andre Rodriguez in a 1990 game.

Running to build cardiovascular strength, as well as for pride in accomplishment, has produced many runners on Oak Park's streets and around the indoor and outdoor tracks at the High School, spawning a number of sponsored races. This 1989 photo shows the annual Boulevard Run. All ages and both sexes participate; the authorities close off streets and have the help of volunteer timekeepers, beverage dispensers, and first aid crew.

Eleven

BUILDING COMMUNITY

Like any other community, Oak Park has its share of parades, celebrations of important national holidays, special events, ceremonies for institutions and customs that are purely local. There have always been veteran's and fraternal organizations, clubs, boy and girl scouts, and events that bring together youth or members of ethnic or religious groups. There have also been events and celebrations of milestones in the life of the community and others that commemorate or try to recapture the past. In addition to the broad based events and programs, others have been confined to one block or neighborhood under the auspices of a parish, a community council, or a local Park District playground. Some of the organizations are gender specific, others have always been coeducational; some have been exclusive and others have been open; some have flourished, others have disappeared.

Whether in the form of a clean-up project, the construction of a playground, painting a mural or participating in a sporting event, mutual aid and community projects are another way to enhance the building of community. Some of the institutions have lasted for generations, others have disappeared and been replaced by new ceremonies, events, and group activities. Most of the manifestations of building community take part within the boundaries of the Village, but some do not. Whether it is an Oak Park group taking part in a parade in Chicago or the display of our architectural heritage at an annual exhibit at the State of Illinois Building, these events also increase the awareness and pride of the citizens in their unique community.

The Block Party has been an ever growing Oak Park tradition for over 30 years, usually in the form of a single street blocked off at both ends. However, there are sometimes multiple block celebrations to include neighbors who live on major arterials. Community tables, games and prizes for the children, and music are standard, though some blocks develop their own traditions. Young Jeffery Clark caries a sign in a mini-parade down his block.

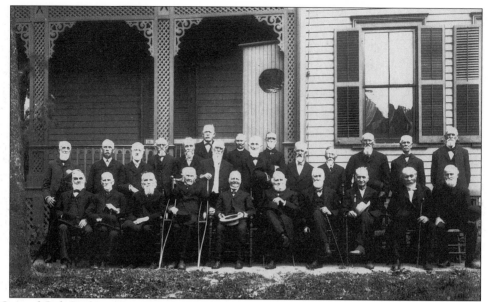

One of Oak Park's unique organizations was the Borrowed Time Club, a group of men who had reached their 70th birthday. Its founder, "Father" Robbins (fifth from right), seated in this 1904 photo, hosted the group informally at his harness shop until they made it official in 1902 and he became the president. There were no dues and the group eventually accepted women. It was the parent to various senior citizen groups.

Founded in 1890 with a membership of 200, the Oak Park Club at Oak Park Avenue and Ontario had two homes before this spacious and well-equipped building opened in 1923. The Club's members included Oak Park's elite for 75 years, but declining interest led to attempts to attract young families in the early 70s. But, its appeal was limited. The club disbanded and the building was redeveloped as luxury condominiums.

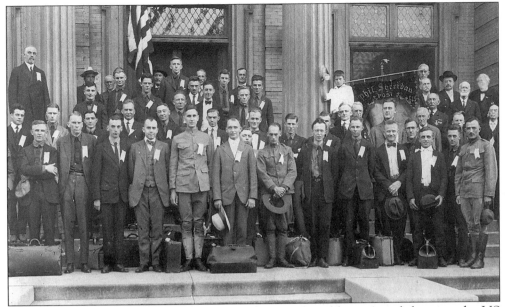

This photo was taken on the steps of the Municipal Building around the time the US entered World War I. The main group is young men going off to war and the older men include a few Civil War veterans who posed to show their solidarity with the young soldiers. The bearded gentleman at the upper far right is A.T. Hemingway, the grandfather of young Ernest. The grandson was not in this detachment, but he served as an ambulance driver in Italy.

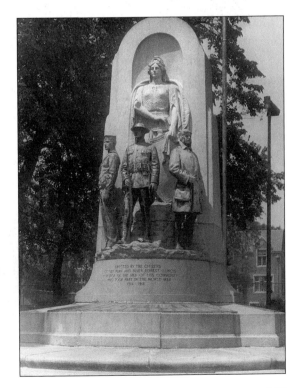

The desire to have a permanent memorial to those who served in World War I produced the War Memorial. Supported by private fundraising, the monument lists the names of those who died in the service of our country. The monument in Scoville Park was dedicated on Armistice (now Veteran's) Day in 1925 with US Vice President C.G. Dawes and General Pershing in attendance.

Memorial Day parades had long been a major annual event in Oak Park, as elsewhere. Elmer Underwood of the local American Legion post participates in this parade through the Oak Park streets in the early 1980s. With the passing of more and more WW II veterans, participation in the parades dwindled, and they have not been held regularly in recent years.

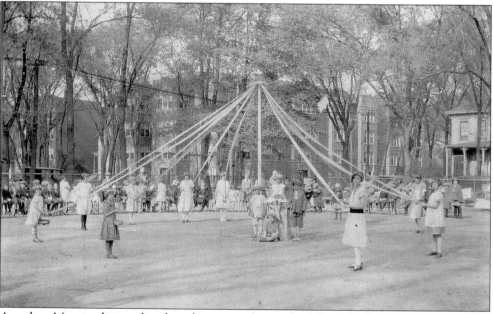

Another May tradition that has disappeared was the Maypole Dance, as depicted in this photo taken sometime between 1917 and 1925. The young women who participate in the event hold both the streamers anchored at the top of a Maypole and hold straw baskets. The scene is at the Junior Playground at the southwest corner of Maple and Randolph, now on the grounds of the OPRF Day Nursery.

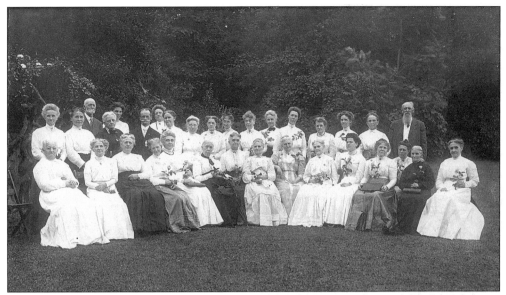

This undated early photo shows members of the women's auxiliary of the Grand Army of the Republic Phil Sheridan Post, an organization that was founded in 1888 by the wives of the men who had served in the Civil War. Though the daughters of such women were welcome and even organized other patriotic organizations, the combination of distance from the war and the lack of local familial continuity caused them to disband.

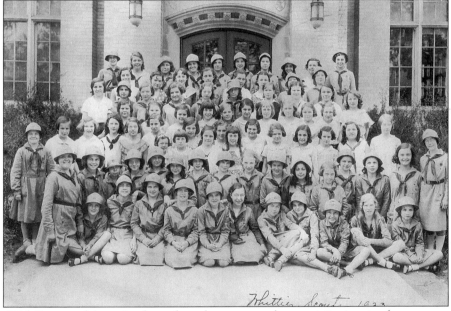

The Girl Scouts of America have long been a popular organization in the community, as attested by the size of the Troop meeting at Whittier School in 1933. Formed in 1920, the local council was incorporated in 1927 and was later absorbed under the larger umbrella known as the Lone Tree Area Council. Brownies, Girl Scouts, and Senior Girl Scouts have met at many locations in the Village through the years.

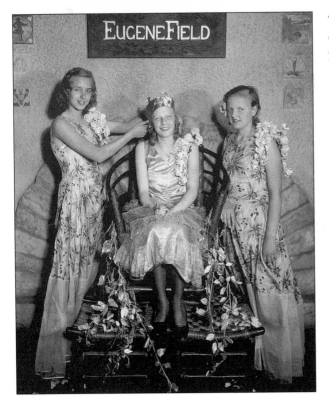

This 1932 photo shows the crowning of a May Queen at a ceremony at the Eugene Field Recreation Center by the members of her court, an event that was duplicated at each of the neighborhood centers' play The identification of a large suburban community with Spring and pagan agricultural rites became less compelling, and such ceremonies disappeared from public observation and awareness. (Photo courtesy of Park District of Oak Park.)

Another crowned young woman, Miss Illinois for 1990 and Miss America for 1991, was Oak Parker Marjorie Vincent. The newly announced winner is shown waving to the crowd amidst the release of hundreds of balloons here in a parade held in her honor on Lake Street in downtown Oak Park. Ms. Vincent was presented as Miss Illinois at the High School by then governor, James Thompson.

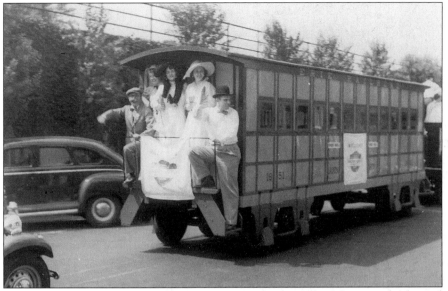

The Golden Jubilee of the Community was commemorated in this parade through the community in August of 1951. Floats and decorated streetcars carried participants dressed in the style of the year when Oak Park broke off from Cicero Township to become an independent municipality. Now approaching the Centennial, the Historical Society of OPRF, the Village Government, and other organizations are making plans for an equally appropriate celebration.

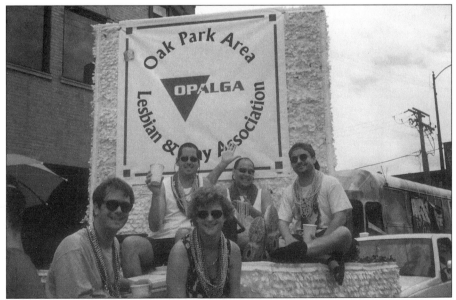

Parades that celebrate community can also represent and celebrate diversity within that community. This 1998 photo depicts a Chicago parade that includes a float and delegation of members of the Oak Park Area Lesbian and Gay Association. An active force for recognition, education, and equal treatment under the law, the membership is inclusive of race, gender, and age. (Photo courtesy of Oak Park Area Lesbian and Gay Association.)

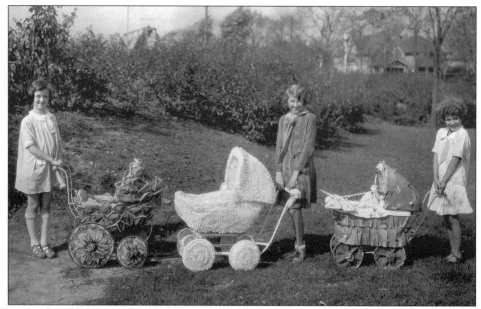

This undated photo taken c.1940 illustrates that not all parades had historical or celebratory roots; some were just fun. The Doll Buggy Parade, probably in Taylor Park, gave young girls a chance to decorate the buggies in imaginative and creative ways, and wheel their dolls in the parade in the hope of winning a prize. (Photo courtesy of Park District of Oak Park.)

Annual dog shows at the local playgrounds have always been popular among the younger set. This 1950 photo shows several young entrants registering for the annual event. Prizes were given for the most obedient, the best trick, and in enough categories to assure a reasonable number of winners. (Photo courtesy of Park District of Oak Park.)

This 1986 photo of Charley and Tom Nelson of Pack 28 Cub Scouts is a pure statement of building community. Wearing their "Help Keep Oak Park Clean" signs, they are picking up trash as part of the Scouts' service mission to the community. Other shared clean up projects have involved organizations and neighborhood partnerships, occasionally including residents of both Oak Park and Austin.

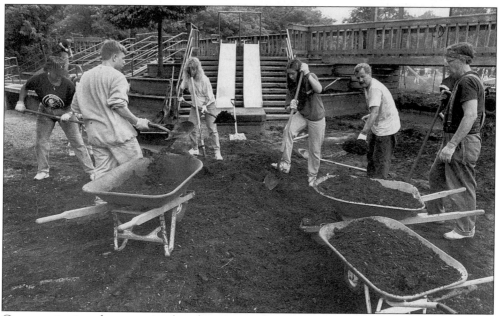

Community involvement in the planning and construction of Oak Park's playgrounds adjacent to the elementary schools has a 20 year history, ever since University of Illinois at Chicago architecture students designed a playground for the community to help build at Longfellow School. In this 1995 photo, we see the ground breaking for the Holmes School playground as parents and neighbors start to make it happen.

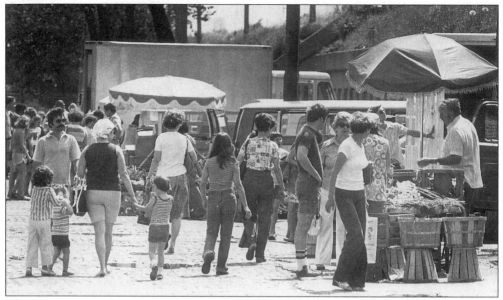

The Farmer's Market is an important Oak Park institution. This 1977 photo shows people spending their Saturday morning picking out fresh produce and visiting with their neighbors in the old site on North Boulevard. The current location in the parking lot of Pilgrim Congregational Church has the advantage of a kitchen to make the ever popular doughnuts as well as adequate space for booths and musical entertainment.

The Oak Park Conservatory is not only a place to come and admire exotic plants in the typical hothouse environment, but is also a symbol of community pride and an education center. Saved from destruction by citizens led by Elsie Jacobson in the early 70s, the Conservatory volunteers help provide plants for Village parks and parkways for the seasonal exhibitions, and for these children and their classmates to grow and keep for their own. (Photo courtesy of Park District of Oak Park.)

For almost 30 years, "A Day in Our Village" has become an important and symbolic event for Oak Park. With informational booths, food, activities, and entertainment originally scattered all over town as a gesture of support for all neighborhoods, the volunteer organized event, as depicted here in June 1997, has been more centralized around Scoville Park in order to limit the need for transportation and to maximize opportunities for socializing. (Photo courtesy of Village of Oak Park.)

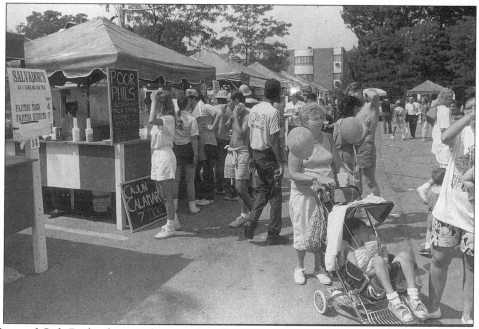

Taste of Oak Park, shown along a closed off South Marion Street, was patterned after the highly successful annual event in Chicago, though it did not achieve the same success. While many food merchants set up booths and entertainment went on into the night, neighbors decried the noise and congestion.

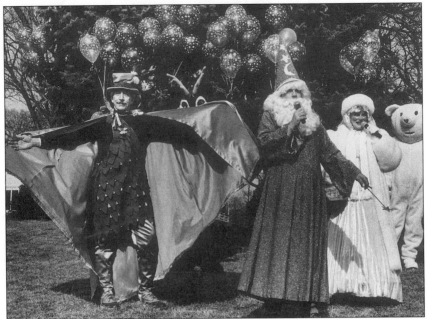

Some festivals and pageants have endured while others have failed to survive. In the latter category was the Winter Carnival, seen in this 1991 photo. Local citizens representing a variety of mythical and literary based characters are shown in full costume on a fortunately dry and not too cold mid-February.

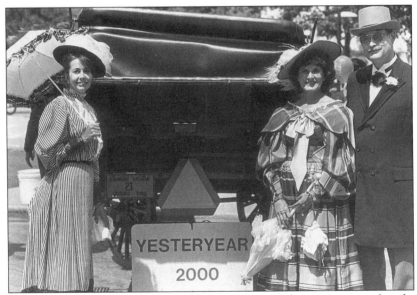

Yesteryear 2000 was an attempt to combine history and pageantry with a backward glance. Pictured in front of an old carriage, in this 1986 photo are: Clifford Osborn, the President of the Village (right), former Health Director Nancy Haggerty, and then member of the Village Board, Patricia Andrews. The upcoming Village Centennial is certain to produce a similar interest in the community's past and celebrate a century of changes.